BETHAN HUWS

Bonnefantenmuseum Maastricht

Kunstverein St.Gallen Kunstmuseum

Verlag der Buchhandlung Walther König, Köln

September 24, 2006 – January 14, 2007
Bonnefantenmuseum, Maastricht,
The Netherlands

February 24 – May 13, 2007
Kunstverein St.Gallen Kunstmuseum,
Switzerland

Content

Discretion and 'working in the dark' are things that Bethan Huws seems cut out for. She is a quiet force in contemporary art. I am delighted to see that such an artist is eligible for the B.A.C.A. The jury, chaired by María de Corral, deserve a special compliment, for nothing escapes their notice. On closer examination we can see that Bethan Huws has drawn inspiration from the achievements of the first generation of conceptual artists, who in turn owe a debt to 'patriarchs' like Marcel Duchamp and René Magritte.

But whereas at first sight Huws appears to be hiding behind the broad backs of her predecessors, her attitude in fact turns out to be much more impudent. She sets out from the premise that concepts like ready-made and site-specific are now such clichés that no contemporary artist would dare embrace them publicly. She deliberately enters the realm of content and meaning via such hackneyed phenomena as *Ceci n'est pas une pipe*. She is not afraid to ride roughshod through the abstraction of so many conceptual notions, and repeatedly violates the symbolism that surrounds Marcel Duchamp's work. Duchamp's fascination for chocolate, so deeply concealed beneath symbolism and metaphor, is robbed of all mystification in Huws' film *The Chocolate Bar*, which shows someone tucking into a Mars bar.

Ready-made or not, Bethan Huws appears to take the numerous connotations that are still to be found in Duchamp's work and put them through the wringer. Yet this will never be at her forerunner's expense, for she does not set out to be destructive. Intriguingly, she succeeds in remaining detached, and never takes things too far. Despite the countless allusions, she manages, for example, to structure her images so that they 'freeze' at a perfectly recognisable poetic level. What we are left with is a poetic discourse that continues imperturbably on its way, and remains itself.

I am very grateful to the jury – María de Corral (chair), Pawel Althamer, Charles Esche and Julian Heynen – for their effort and insight. Their friendship has been heartwarming. I would also like to thank Océ N.V. for their immediate willingness to sponsor the process, and also the Province of Limburg and Maastricht City Council.

Alexander van Grevenstein
June 2006

Diskretion und ,working in the dark' scheinen Bethan Huws wie auf den Leib geschrieben. Sie ist eine stille Kraft in der heutigen Kunst. Ich freue mich, dass eine solche Künstlerin für den B.A.C.A. in Betracht kommt. Die Jury unter dem Vorsitz von María de Corral verdient ein Kompliment. Ihr entgeht nichts. Wenn wir nämlich etwas weitersehen, fällt auf, das Bethan Huws sich auf die Errungenschaften der ersten Generation der konzeptuellen Künstler stützt, die wiederum ihre Verpflichtungen gegenüber ,Urvätern' Marcel Duchamp und René Magritte haben.

Was jedoch in erster Linie als ein Verstecken hinter den breiten Rücken der Vorgänger erscheint, stellt sich bei näherer Betrachtung als Ergebnis einer viel frecheren Haltung heraus. Huws Ausgangspunkt beruht schließlich auf der Tatsache, dass Begriffe, wie ready-made und site-specific, inzwischen zu Klischees geworden sind, die sich kein Künstler heute noch öffentlich zu umarmen traut. Bethan Huws schreitet über die abgegriffensten Phänomene, wie z.B. *Ceci n'est pas une pipe* zielbewusst in die Welt des Inhalts und der Bedeutung. Sie schreckt nicht davor zurück, regelmäßig mit Stiefeln durch das hohe Abstraktionsniveau vieler konzeptueller Einsichten zu laufen, wodurch der Symbolik, die Marcel Duchamp in und um seine Arbeiten anzubringen weiß, dabei mehrmals Gewalt angetan wird. Duchamps Faszination für Schokolade, so verborgen hinter Symbolik und Metaphern, wird von Huws von jeglicher Mystifikation befreit, wenn sie in dem Film *The Chocolate Bar* jemand ein Mars mit Genuss verzehren lässt.

Es hat allen Anschein, dass die vielen Konnotationen, die noch in den Arbeiten von Duchamp verborgen liegen, trotz der Tatsache des ready-made von Bethan Huws durch die Mangel gedreht werden. Dennoch geschieht dies nie auf Kosten ihres Vorbilds, denn ihre Absicht ist nicht destruktiv. Auf eine interessante Art versteht sie es, Distanz zu wahren, und geht dabei nicht zu weit. Trotz der zahllosen Anspielungen weiß sie zum Beispiel ihre (Film)bilder so zu strukturieren, dass diese auf einem äußerst einfühlsamen poetischen Niveau ,gefrieren'. Das Ergebnis ist ein poetischer Diskurs, der unbeirrbar fortschreitet und das bleibt, was er ist.

Ich danke der Jury, bestehend aus María de Corral (Vorsitzende), Pawel Althamer, Charles Esche und Julian Heynen, für ihr Engagement und ihre Einsicht. Ihre Freundschaft war äußerst herzlich. Ich danke ebenfalls der Océ N.V. für ihre schnelle Reaktion, diesen Prozess finanziell zu ermöglichen, ebenso wie der Provinz Limburg und der Stadt Maastricht.

Alexander van Grevenstein
Juni 2006

Translation – Transposition
On Bethan Huws' Artistic Approach

"2 MAJOR EVENTS / 1. Displacement / 2. TURNING (MAKING) REFLECTION."

<div align="right">Bethan Huws[1]</div>

Prelude

The thought of putting Huws' oeuvre into words, thus tying it down, is enough to make
any critic hesitate. Not only is her art based on a complex, self-testing thought process
that avoids any one-sided fixation. Her work above all manifests itself in semantic
structures – just as much as does the critical reflection. Preceded by the artist's intense
occupation with linguistic questions, the oeuvre revolves around the possibilities of
'translation': from thought into form, from one medium into another, from one
language into another, from one cultural sphere into another – respectively resulting in
thematic transformations and poetic openings. And so you write your way along a
tightrope between the work's own mental precision and its meticulous fixation, while
you constantly preserve the greatest possible openness towards just this work. What
still may seem conceivable in the study of selected works or single work groups,
is condemned to failure in the following attempt to see the oeuvre as a whole in all its
complex ramifications: "AN ARTWORK IS MADE OF ONE THING – A PERSON". [2]

Starting Point

'ON / ON KAWARA' – this is how *Untitled* (2006) begins, with two brief lines and the
play on words made possible by the English preposition and the Japanese first name,
a work that the artist realized at Kunstmuseum St.Gallen for the exhibition *Mental
Image*.[3] Invited to exhibit works in the same room with the Japanese master, Bethan
Huws could not resist the opportunity for an intellectual engagement with On Kawara's
paintings. She did so by dedicating to him a *Word Vitrine*, the name she gave a work
series, ongoing since 1999. Which is, in principle, standard commercial metal boxes
equipped with a glass front and a back wall in black that, with flexible, snap-in, white

plastic letters, serve to convey all kinds of information and are found, among other places, in offices or restaurants for displaying the price of drinks, for instance. Bethan Huws now transforms the utilitarian object into an aesthetic statement and 'fills' it with her own contents – whereby the idea of 'filling' does in no way justice to her subtle, often very humorous texts. Here she takes over the structure of On Kawara's *Today* paintings, which represent only the date on which they were produced. Consequently, Bethan Huws appends to her *Word Vitrine* the date of origin, "31.03.2006", then closes with the short text: "Fully aware of all that / passes in the world around him, On / Kawara chooses to sit/stand / quietly painting his painting." With a simple gesture she pays her respects to this pioneer of conceptual art. At the same time, in her own work she discloses her historical sources, as she had previously done in allusion to (among others) René Magritte, Yves Klein, Carl Andre and, repeatedly, to Marcel Duchamp. These traditions she obviously wants to re-interpret and test as to their contempo-raneity. In short: Bethan Huws seems not only to embed her work in an art-historical, but also an intellectual, context. The conceptual roots and the fundamental questioning as to the conditions and possibilities for art remain, however, a tangible concern. Nonetheless, what is made very clear is that the gesture in *ON / ON KAWARA* goes far beyond an uncritical 'appropriation'. Thus the deployment of a non-art object as 'picture support' – On Kawara, in contrast, uses the genre of the traditional easel painting – as well as of language as a primary medium is a deliberate ruse to reconnect art to the everyday world. This tie-in is also underlined in Bethan Huws' supplementary text that relates the artist's creative process to what passes around him, i.e., his immediate present. By means of such formal as well as thematic pointers, she conceives a complex system of coordinates by means of which her own work is constantly being newly positioned between a subjective grounding in the individual person and a precise anchoring in cultural history, between the hermeticism of the aesthetic process – i.e., the mental impetus translated into forms – and a decisive opening to the world. The permanent oscillation between the inward and outward view may likewise be valid for other artists, but in Bethan Huws' oeuvre it is accompanied by a constant questioning of her own position and, thus, always kept to a state of inner instability despite all the

ON

ON KAWARA

31 · 03 · 2006

Fully aware of all that passes
in the world around him, On
Kawara chooses to sit/stand
quietly painting his painting.

formal and intellectual precision: "1) First you do something / 2) then you question what you did. This is making."[4]

Beginning – Positioning

Bethan Huws' artistic beginnings were defined by her moves to secure and position herself in the world of art. Her 1987 installation *Scraped Floor* set a determined counterpoint to the spectacular appearances of the Young British Artists. As a student at the Royal College of Art in London she scraped clean a corner of her studio of all its accumulated layers down to the wooden floor. We can see this minimal gesture as an attempt to define her own artistic space, the goal a kind of self-assurance, because "as an artist/person she as yet had 'no relationship to herself' (B.H.)".[5] From this still muted self-determination there subsequently evolved her self-confident occupation of exhibition rooms, as in the interventions – just as formally minimalist as they were intellectually precise – at the Riverside Studios (1989) or the Kunsthalle Bern (1990), in which parts of the gallery floor were doubled, thoroughly re-orienting the room. These installations have made her works a known feature in the art world. Even if parallels to simultaneous critical stands towards institutions can be seen, these are often limited to an art-immanent discourse, whereas with Bethan Huws they are only one possible aspect of her work, which is complemented by others, even at times called into question – at least on the surface. Thus, parallel to these, the artist fashioned the so-called *boats*, fragile miniatures she shaped out of a rush. By her interventions into the room and the institution, she laid down a thematic frame of reference within the world of art, whereas with her *boats* Bethan Huws executed a crucial change of direction. As a child, she had made just such boats and set them free to drift on the water. Like precious gems exhibited 'classically' on pedestals under Plexiglas domes, these artifacts now stress the discrepancy between the fleetingness of a carefree children's game and an artwork's claim to eternity: memory is activated, translated into art and simultaneously conserved. Despite the radicalness of this questioning of museal presentations and the resulting auratization, an immediate intimacy remains tangible, which also resonates in the artist's works on paper. In this transient medium Bethan

Huws also changes the perspective – away from the purely art-immanent discourse (that very slyly flares up in drawings such as *Marcel Duchamp's Turn*) and towards memories of an understandable, familiar world, the world of her childhood and her Welsh homeland with the hilly countryside, its people and animals... Meanwhile the works on paper seem strangely here-and-now, their lines just as spontaneous as predetermined. Contours are very delicately suggested in watercolor like traces of memory concentrated down to the essential and mostly isolated in a pictorial area within the paper's borders, as if the things of her youth needed shelter from the bustling art world. With all their formal ingenuity, what is striking is the economical use of the drawing approach. The works on paper never seem to illustrate; for that the pictorial vocabulary is too open, too ephemeral. Bethan Huws seems to dodge the medium's own conventions with a certain formal cumbrousness and to opt out of any linear legibility by condensing her depiction of things. In gentle allusions, the works on paper open up those spaces to perception and cognition so essential to her oeuvre. It almost seems as if the artist wanted this intimate format to safeguard her origin and with it her identity via the means of drawing, like "trying out a construction that creates a single entity combining a real piece of the world, the 'I', and the question as to the possibilities of art."[6]

Text and Context

The same insistent and open view of the world can be found in a radical form in texts such as *The Lake Writing* (1991), a kind of conceptual landscape. The artist meticulously transcribed on paper her detailed observations of *Llyn Idwal*, a lake in north Wales: changes in the weather, the light... Written without paragraphs, the pages were subsequently exhibited in the Nash Room of the London ICA, where the act of reading them mentally resurrected the landscape. Bethan Huws' attempt – in fact, hopeless – at a most inclusive as possible description of all her perceptions, via their mental reconstruction, generates a variety of scenes; the observed landscape becomes an imagined picture, endlessly refracted. What however always remains tangible is the unbridgeable discrepancy between inside and out, between the territories of art and

nature and, therefore, between the refined décor of English highbrow culture and the direct experience of the Welsh countryside. "TO MAKE SOMETHING YOU HAVE TO START SEEING DIFFERENCES, DISCONTINUITY..."[7] The term 'displacement' is a kind of transposition that characterizes the clash between cultural backgrounds that pervades the artist's oeuvre with its metaphoric passage from one into the other, beginning with the rush boats, via the site-specific interventions, up to the films, such as the impressive *Singing for the Sea* (1993) where the Bulgarian women's choir pay homage to the sea on the Northumberland coast, or the almost one-hour *ION ON* (2003), a zany dialogue on the complex relationship between artist and curator against a romantic landscape of ruins.

Such a cursory work survey can only hint at the rich variety of Bethan Huws' oeuvre. Nevertheless in outline form, there are basic artist's strategies to be seen here. In her flashback to Modernism's radical positions – to Marcel Duchamp's epochal gesture and Conceptual Art's dematerialization of objects in the 1960s, as well as to new present-day interpretations of these – her work shows parallels to the positions often termed 'postconceptual' of artists like Ayşe Erkmen, Karin Sander or Jonathan Monk. Their works too cannot be formally fixed and – starting from a fundamental questioning of art and its operating mechanisms – revolve around a great variety of media. While Jonathan Monk (*1969) breaks up the 'objective' rules of Minimal and Conceptual Art using his own person or the profane traditions of English beer-drinking culture and thus reduces these older positions' historical claim to validity to absurdity, Ayşe Erkmen (*1949), who lives in Berlin and Istanbul, misappropriates cultural points of fracture, whether it be by exhibiting in an art museum taxidermal specimens that she borrows from a natural history museum within the same building or by having Venice and Bosporus ferries do service on the Main River in Frankfurt. Bethan Huws' minimalist interventions into surrounding space also find surprising parallels in the floor works of Karin Sander (*1957). Like these named artists, Bethan Huws too vehemently disrupts the implied or even explicitly formulated art traditions in her work via the everyday world and, by means of unexpected transformations, ties their inherent self-referentiality to life's reality, to one's own experience and feeling. Transpose and translate, displace and

interchange: for this artist – born in Wales, trained in London and today a resident of Paris – what always plays a crucial role is her own remembrance of things past, and with it the question of cultural identity. All this is translated into rich works of art, subtle in poetry and fine in humor.

Konrad Bitterli

From the German by Jeanne Haunschild

1 *Origin and Source*, 1993–June 1995, Volume IV, p. 147.
2 See fn. 1: Volume I, p. 61.
3 *Mental Image – Wortwerke und Textbilder*, Kunstmuseum St.Gallen, 8.4.–14.5.2006, with works by Lawrence Weiner, Rémy Zaugg, Silvie and Chérif Defraoui, Alex Hanimann, Raymond Pettibon, Fernando Bryce, Andres Lutz / Anders Guggisberg, and others.
4 See fn. 1: Volume IV, p. 78.
5 Julian Heynen, "ION ON – A Film", in: *Bethan Huws, Selected Textual Works 1991–2003*, published by Dieter Association, Paris and Kunsthalle Düsseldorf, 2003, p. 164.
6 Julian Heynen, "I want to try to remember the drawings", in: Kat. *Bethan Huws – Watercolours*, Kaiser Wilhelm Museum Krefeld, 1998, p. 123.
7 See fn. 1: Volume VI, p. 56.

Übersetzen – Versetzen
Zu Bethan Huws' künstlerischer Praxis

„2 MAJOR EVENTS / 1. Displacement / 2. TURNING (MAKING) REFLECTION.“

<div align="right">Bethan Huws[1]</div>

Avant-propos

Bethan Huws' Schaffen in Worten zu fassen und damit festzuschreiben lässt jeden
Kritiker zögern. Nicht nur gründet ihre künstlerische Praxis in einem vielschichtigen,
sich stets selbst überprüfenden gedanklichen Prozess, der sich jeder einseitigen
Festlegung zu entziehen sucht. Vor allem aber manifestiert sich ihr Werk in sprach-
lichen Strukturen – genauso wie die kritische Reflexion darüber. Dem geht eine
intensive Beschäftigung mit linguistischen Fragestellungen voraus, wobei das Œuvre
um Möglichkeiten des ‚Übersetzens‘ kreist: vom Gedanklichen in die Form, von einem
Medium in ein anderes, von einer Sprache in eine andere, von einem Kulturraum in
einen anderen – mit den jeweils resultierenden inhaltlichen Transformationen und
poetischen Öffnungen. Und so begibt man sich schreibend auf eine Gratwanderung
zwischen der dem Werk eigenen gedanklichen Präzision und seiner akkuraten Fest-
Schreibung bei stetiger Wahrung einer grösstmöglichen Offenheit gegenüber eben
diesem Werk. Was bei der Beschäftigung mit ausgewählten Arbeiten oder einzelnen
Werkgruppen zumindest ansatzweise noch denkbar erscheint, ist bei dem im
Folgenden unternommenen Versuch, das Œuvre in seinen komplexen Verästelungen
immer als Ganzes zu sehen, zwangsweise zum Scheitern verurteilt: „AN ARTWORK IS
MADE OF ONE THING – A PERSON.“[2]

Ansetzen

‚ON / ON KAWARA‘ – mit zwei knappen Zeilen und dem durch die englische Präposi-
tion sowie den japanischen Eigennamen ermöglichten Wortspiel beginnt *Untitled*
(2006), eine Arbeit, welche die Künstlerin für die Ausstellung *Mental Image* im
Kunstmuseum St.Gallen realisiert hat.[3] Eingeladen, im selben Raum mit dem japani-
schen Altmeister auszustellen, liess es sich Bethan Huws nicht nehmen, sich den

Gemälden von On Kawara gedanklich zu stellen. Sie tat dies, indem sie ihm eine *Word Vitrine* widmete, so die Bezeichnung für ihre seit 1999 entstehende Werkserie. Es handelt sich dabei im Prinzip um handelsübliche Metallkästen, versehen mit Glasfront und schwarzer Rückwand, die mit flexibel steckbaren, weissen Plastikbuchstaben der Vermittlung von Information aller Art dienen und sich u. a. in Amtsstuben oder in Restaurants finden, um ganz sachlich zum Beispiel die Preise für Getränke anzuschreiben. Bethan Huws nun transformiert das Gebrauchsobjekt zur künstlerischen Aussage und ,füllt' es mit eigenen Inhalten – wobei die Vorstellung des ,Füllens' ihren subtilen, durchaus humorvollen Texten in keiner Weise gerecht wird. Hier übernimmt sie die Struktur von On Kawaras *Today*-Bildern, die einzig das Datum wiedergeben, an dem sie geschaffen wurden. Konsequent fügt Bethan Huws ihrer *Word Vitrine* den Entstehungstag bei, 31.03.2006, um mit einem kurzen Text abzuschliessen: „Fully aware of all that / passes in the world around him, On / Kawara chooses to sit/stand / quietly painting his painting." Mit einer simplen Geste erweist sie dem Pionier der Konzeptkunst ihre Reverenz. Zugleich legt sie im eigenen Werk historische Quellen offen, wie sie es zuvor u. a. im Bezug auf René Magritte, Yves Klein, Carl Andre und wiederholt auf Marcel Duchamp getan hatte. Diese Traditionen scheint sie neu interpretieren und auf ihre Aktualität hin überprüfen zu wollen. Kurz: Bethan Huws versucht, ihr eigenes Schaffen nicht nur kunsthistorisch, sondern auch gedanklich einzubetten. Stets jedoch bleiben der konzeptuelle Ansatz und die grundlegende Befragung der Bedingungen und Möglichkeiten von Kunst als Anliegen spürbar. Dass die Geste jedoch weit über eine kritiklose ,Appropriation' hinausgeht, verdeutlicht *ON / ON KAWARA*. So bedeutet die Verwendung eines kunstfremden Gegenstandes als ,Bildträger' – On Kawara benutzt dagegen die traditionelle Gattung des Tafelbildes – sowie der Sprache als primäres Medium eine gezielte Rückbindung der Kunst an den Alltag und an die Lebenswelt. Diesen Zusammenhang unterstreicht auch Bethan Huws' ergänzender Text, der den Schaffensprozess des Künstlers in Bezug setzt zu dem, was um ihn herum passiert, d. h. zur unmittelbaren Gegenwart. Mit solchen formalen wie inhaltlichen Verweisen entwirft sie ein komplexes Koordinatensystem, in dem sich das eigene Werk immer wieder neu verortet zwischen der subjektiven Begründung im Individuum und der

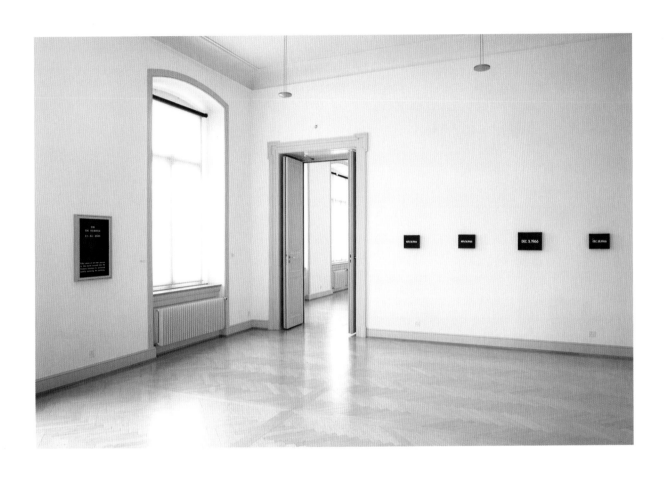

präzisen Verankerung in der Kulturgeschichte, zwischen der Hermetik des künstlerischen Prozesses – d. h. den gedanklichen Bewegungen und den daraus resultierenden Formfindungen – und einer entschiedenen Öffnung hin zur Welt. Das permanente Oszillieren zwischen Innen- und Aussensicht mag für andere Kunstschaffende ebenfalls gelten, in Bethan Huws' Œuvre jedoch wird es begleitet von einem nie nachlassenden Hinterfragen der eigenen Position und dadurch bei aller formalen wie gedanklichen Präzision immer in einem Zustand innerer Labilität gehalten: „1) First you do something / 2) then you question what you did. This is making."[4]

Anfangen – Positionieren

Bethan Huws' künstlerische Anfänge waren bestimmt durch ein Sich-Versichern und Sich-Positionieren in der Welt der Kunst. Zu den spektakulären Auftritten der Young British Artists setzt ihre Installation *Scraped Floor* (1987) einen entschiedenen Kontrapunkt. Als Studentin am Royal College of Art in London legt sie eine Ecke ihres Ateliers bis auf den Holzboden von Überlagerungen frei. Man kann diese minimale Geste als Versuch sehen, einen eigenen künstlerischen Raum zu bestimmen mit dem Ziel einer Art ‚Selbstvergewisserung', weil sie als „Künstlerin/Person bislang ‚keine Beziehung zu sich selbst' (B.H.) besass".[5] Aus der noch verhaltenen Selbstbestimmung entwickelt sich in der Folge ein selbstbewusstes Besetzen von Ausstellungsräumen, etwa in den formal ebenso minimalistischen wie gedanklich präzisen Interventionen in den Riverside Studios (1989) oder der Kunsthalle Bern (1990), bei denen Teile des Galeriebodens aufgedoppelt werden und damit den Raum völlig neu ausrichten. Diese Installationen verankern ihr Schaffen nachhaltig in der Kunstwelt. Auch wenn sich Parallelen zu zeitgleichen institutionskritischen Haltungen beobachten lassen, beschränken sich letztere oft auf einen kunstimmanenten Diskurs, während sie bei Bethan Huws nur einen möglichen Werkstrang ausbilden, der durch andere ergänzt, zuweilen gar in Frage gestellt wird – zumindest vordergründig. So entstehen parallel dazu die sogenannten *Boote*, diese aus einem Rietgras geformten fragilen Miniaturen. Während bei den Interventionen der Raum und die Institution, d.h. die Welt der Kunst, den inhaltlichen Referenzrahmen vorgeben, vollzieht Bethan Huws mit den *Booten*

eine entschiedene Wendung. Als Kind hatte sie nämlich solche Boote gefertigt und auf dem Wasser treiben lassen. Wie Preziosen ‚klassisch' auf Sockeln unter Plexiglashauben ausgestellt, betonen die Artefakte die Diskrepanz zwischen der Vergänglichkeit des fröhlichen Kinderspiels und dem Ewigkeitsanspruch des Kunstwerks: Erinnerung wird aktiviert, in Kunst übersetzt und zugleich konserviert. Bei aller Radikalität der Befragung musealer Präsentationsbedingungen und der damit verbundenen Auratisierung bleibt eine unmittelbare Intimität spürbar, wie sie auch im zeichnerischen Œuvre der Künstlerin anklingt. Auch in diesem als flüchtig bezeichneten Medium wechselt Bethan Huws die Perspektive – weg vom rein kunstimmanenten Diskurs, der in Blättern wie *Marcel Duchamp's Turn* zwar immer auch listig aufblitzt, hin zu Erinnerungen an eine überschaubare, vertraute Welt, an die Welt ihrer Kindheit und ihrer walisischen Heimat mit den hügeligen Landschaften, den Menschen und Tieren... Dabei erscheinen die Blätter eigenartig gegenwärtig, wirkt ihr Strich ebenso spontan gesetzt wie bestimmt. Umrisse sind im Aquarell zart angedeutet als aufs Wesentliche konzentrierte Erinnerungsspuren, meist isoliert im Geviert des Papiers, als würden die Dinge ihrer Jugend eines Schonraumes für die betriebsame Kunstwelt bedürfen. Bei aller formalen Raffinesse fällt der ökonomische Einsatz der zeichnerischen Mittel auf: Nie wirken die Blätter illustrativ, dafür bleibt die Bildsprache zu offen, zu ephemer. Die dem Medium eigenen Konventionen sucht Bethan Huws mit einer gewissen formalen Sperrigkeit zu unterlaufen und verweigert sich in der Konzentration der Dinge jeder linearen Lektüre. In sanften Andeutungen öffnen die Blätter jene Räume der Wahrnehmung und des Denkens, die für ihr Schaffen so entscheidend sind. Es scheint beinahe, als wolle sich die Künstlerin im intimen Format ihrer Herkunft und damit ihrer Identität zeichnerisch versichern, als Versuch einer „Konstruktion, die ein reales Stück Welt mit dem Ich und der Frage nach der Möglichkeit von Kunst zu einer Einheit verbindet".[6]

Text und Kontext

Derselbe insistierende wie öffnende Blick auf die Welt findet sich in radikaler Form in Textarbeiten wie dem *The Lake Writing* (1991), einer Art konzeptueller Landschaftsdarstellung. Detaillierte Beobachtungen am *Llyn Idwal*, einem See im Norden von Wales,

transkribiert die Künstlerin akribisch auf Papier: Veränderungen des Wetters, des Lichts… Anschliessend werden die ohne Absatz beschriebenen Blätter im Nash-Saal des Londoner ICA ausgestellt und lassen die Landschaft im Akt des Lesens gedanklich auferstehen. Bethan Huws' im Grunde hoffnungsloser Versuch einer möglichst umfassenden Beschreibung all ihrer Wahrnehmungen generiert im gedanklichen Nachvollzug unterschiedliche Orte, die gesehene Landschaft wird zum imaginierten Bild – in endloser Brechung. Stets spürbar jedoch bleibt die unüberbrückbare Diskrepanz zwischen dem Innen und dem Aussen, zwischen Kunst- und Naturraum und damit zwischen dem verfeinerten Dekor englischer Hochkultur und dem unmittelbaren Erleben der walisischen Landschaft. „TO MAKE SOMETHING YOU HAVE TO START SEEING DIFFERENCES, DISONTINUITY…"[7] Im Englischen mit dem Begriff ‚displacement' bezeichnet, durchdringt das Aufeinanderprallen von Kulturräumen, dieses metaphorische ‚Versetzen' des einen ins andere das Œuvre der Künstlerin, angefangen mit den Rietgras-Booten über die ortspezifischen Interventionen bis zu Filmarbeiten wie dem eindrücklichen *Singing for the Sea* (1993) mit dem bulgarischen Frauenchor, der an der Küste Northumberlands das Meer besingt, oder dem beinahe einstündigen *ION ON* (2003), einem irrwitzigen Dialog über das komplexe Verhältnis von Künstler und Kurator vor romantischer Ruinenlandschaft.

Ein solch kursorischer Werküberblick kann den Reichtum von Bethan Huws' Schaffen nur andeuten. Dennoch treten zugrunde liegende künstlerische Strategien in Konturen hervor. In der Rückbesinnung auf die radikalen Positionen der Moderne, namentlich die epochale Geste von Marcel Duchamp und die Auflösung des künstlerischen Artefakts in der Konzeptkunst der sechziger Jahre, sowie deren Neuinterpretation für die Gegenwart weist ihr Schaffen Parallelen auf zu den oftmals als ‚postkonzeptuell' bezeichneten Haltungen, zu Künstlern wie beispielsweise Ayşe Erkmen, Karin Sander oder Jonathan Monk. Auch deren Schaffen lässt sich formal nicht festschreiben und bewegt sich, ausgehend von einer grundlegenden Befragung der Kunst und ihrer Wirkmechanismen, zwischen unterschiedlichsten Medien. Während Jonathan Monk (*1969) das ‚objektive' Regelwerk der Minimal und Conceptual Art an der eigenen Person und an den profanen Traditionen englischer Biertrinkkultur bricht und damit

den historischen Gültigkeitsanspruch dieser Positionen vollends ad absurdum führt, bearbeitet die in Berlin und Istanbul lebende Ayşe Erkmen (*1949) kulturelle Bruchstellen, sei dies indem sie in einem Kunstmuseum Präparate des im selben Gebäude befindlichen Naturmuseums ausstellt, sei dies indem sie ein Venezianisches Vaporetto und ein Fährschiff vom Bosporus auf dem Main in Frankfurt Dienst tun lässt. Aber auch Bethan Huws minimalistische Raumintervention finden überraschende Parallelen in den Bodenarbeiten von Karin Sander (*1957). Wie die stellvertretend Genannten bricht auch Bethan Huws die im Werk angedeuteten oder gar explizit formulierten künstlerischen Traditionen stets vehement am Alltäglichen und bindet deren inhärente Selbstbezüglichkeit mittels unerwarteter Transformationen an die Lebenswirklichkeit, ans eigene Erleben und Empfinden. Versetzen und Übersetzen: Immer spielen für die in Wales geborene, in London ausgebildete und heute in Paris lebende Künstlerin das eigene Erinnern und damit verbunden die Frage nach der kulturellen Identität eine wesentliche Rolle – und finden sich übersetzt in ein reiches künstlerisches Werk von subtiler Poesie und feinem Humor.

Konrad Bitterli

1 *Origin and Source*, 1993–June 1995, Volume IV, p. 147.

2 Wie FN 1: Volume I, p. 61.

3 *Mental Image – Wortwerke und Textbilder*, Kunstmuseum St.Gallen, 8.4.–14.5.2006, mit Werken u. a. von Lawrence Weiner, Rémy Zaugg, Silvie und Chérif Defraoui, Alex Hanimann, Raymond Pettibon, Fernando Bryce, Andres Lutz / Anders Guggisberg.

4 Wie FN 1: Volume IV, p. 78.

5 Julian Heynen, „ION ON – ein Film", in: *Bethan Huws, Selected Textual Works 1992–2003*, herausgegeben von Dieter Association, Paris und Kunsthalle Düsseldorf, 2003, p. 167.

6 Julian Heynen, „Ich will versuchen, mich an die Zeichnungen zu erinnern", in: Kat. *Bethan Huws – Watercolours*, Kaiser Wilhelm Museum Krefeld, 1998, p. 93.

7 Wie FN 1: Volume VI, p. 56.

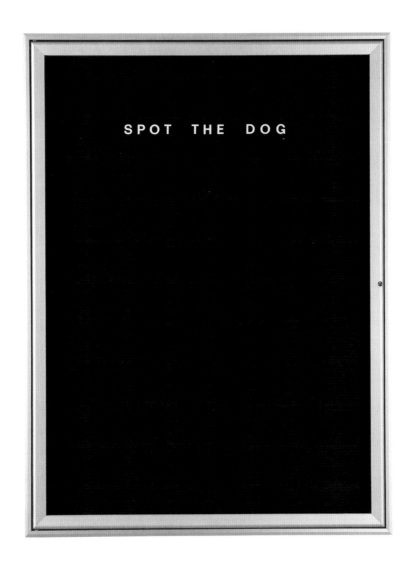

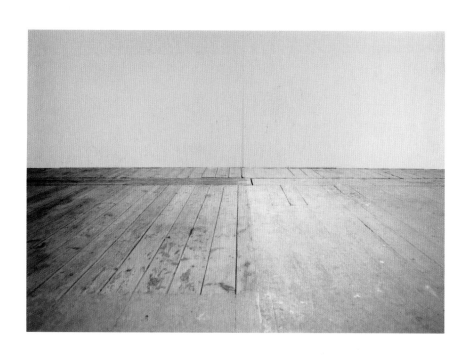

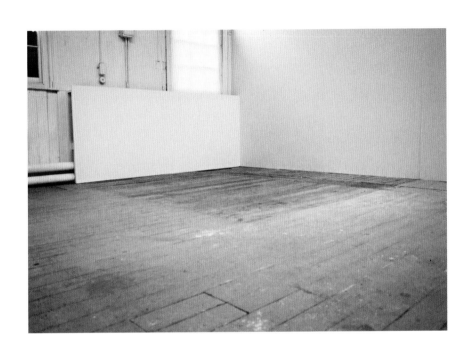

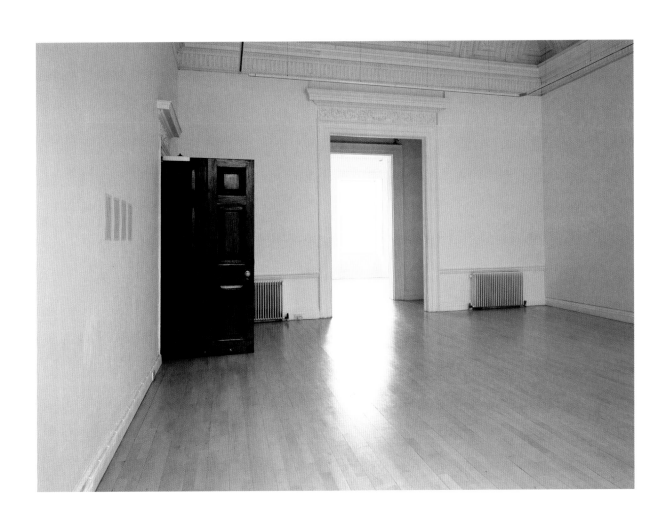

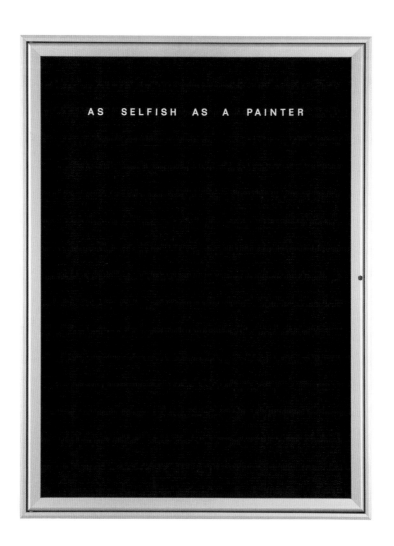

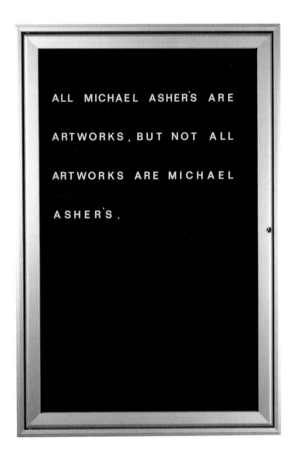

WHICH CAME FIRST THE CHICKEN

OR THE EGG?

THE EGG

AS IT'S THE MORE PRIMITIVE

FORM

THAT'S LOGIC

ALL MICHAEL ASHER'S ARE

ARTWORKS, BUT NOT ALL

ARTWORKS ARE MICHAEL

ASHER'S.

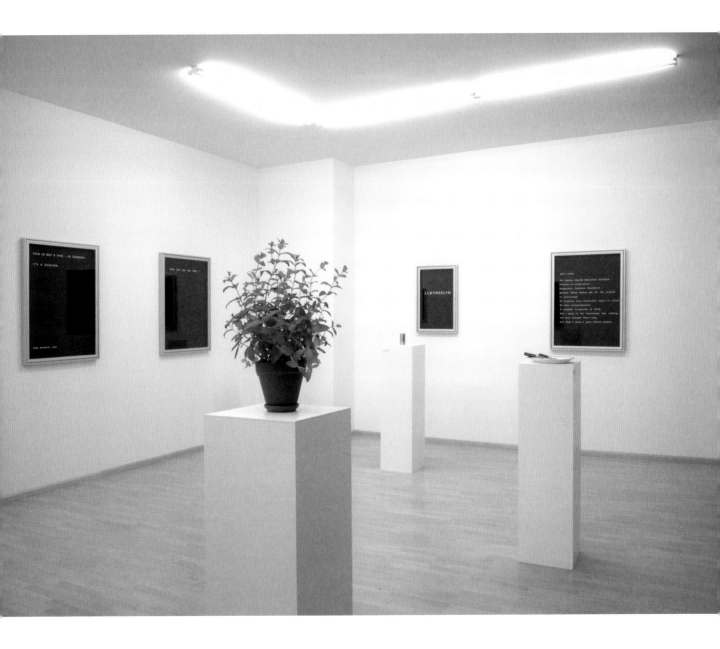

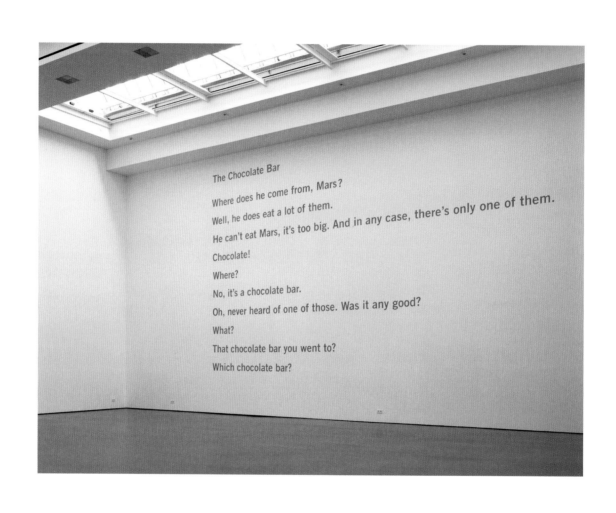

The Chocolate Bar

Where does he come from, Mars?

Well, he does eat a lot of them.

He can't eat Mars, it's too big. And in any case, there's only one of them.

Chocolate!

Where?

No, it's a chocolate bar.

Oh, never heard of one of those. Was it any good?

What?

That chocolate bar you went to?

Which chocolate bar?

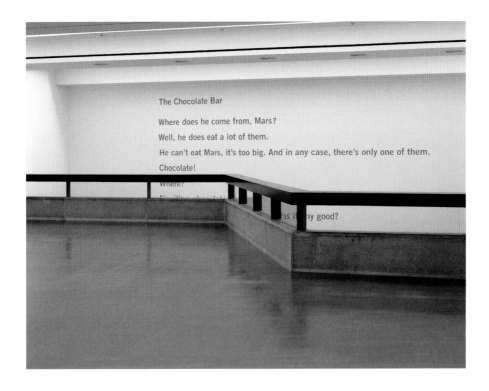

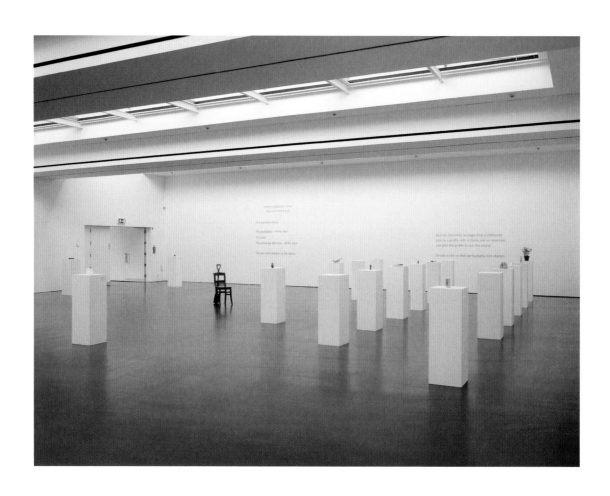

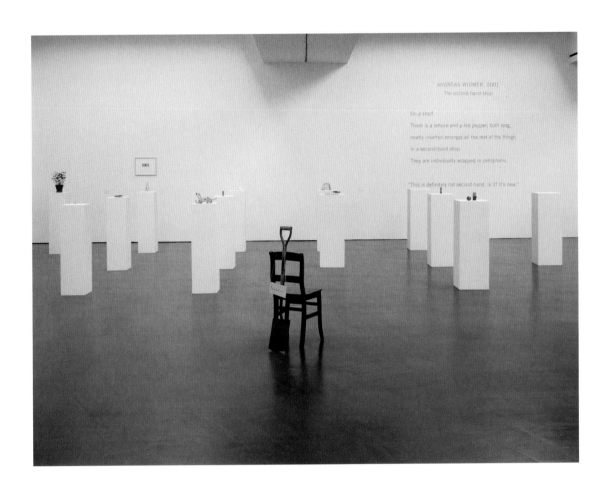

ANDREAS WIDMER, 2001
The second-hand shop

On a shelf
There is a lettuce and a red pepper, both long,
neatly inserted amongst all the rest of the things
in a second-hand shop.
They are individually wrapped in cellophane.

"This is definitely not second-hand. Is it? It's new."

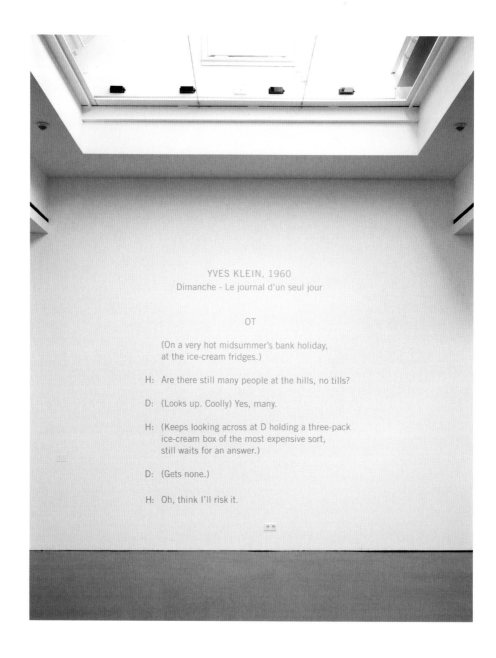

YVES KLEIN, 1960
Dimanche - Le journal d'un seul jour

OT

(On a very hot midsummer's bank holiday,
at the ice-cream fridges.)

H: Are there still many people at the hills, no tills?

D: (Looks up. Coolly) Yes, many.

H: (Keeps looking across at D holding a three-pack
ice-cream box of the most expensive sort,
still waits for an answer.)

D: (Gets none.)

H: Oh, think I'll risk it.

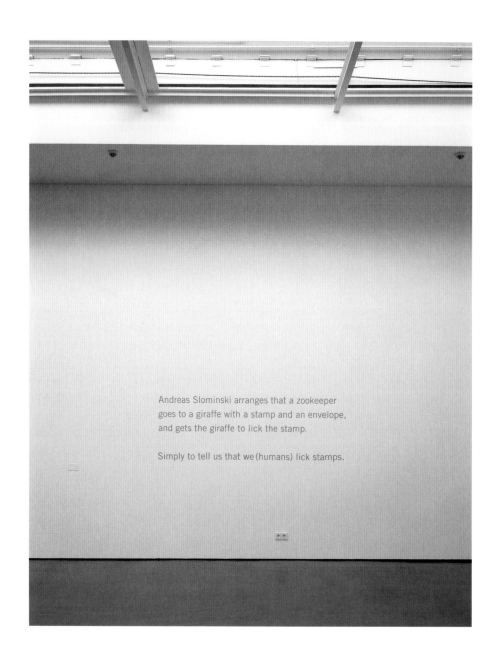

Andreas Slominski arranges that a zookeeper
goes to a giraffe with a stamp and an envelope,
and gets the giraffe to lick the stamp.

Simply to tell us that we (humans) lick stamps.

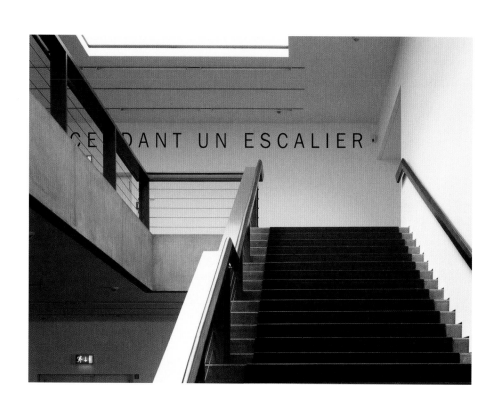

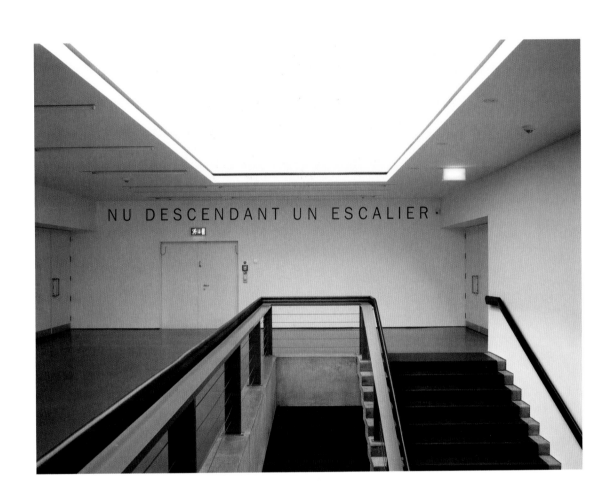

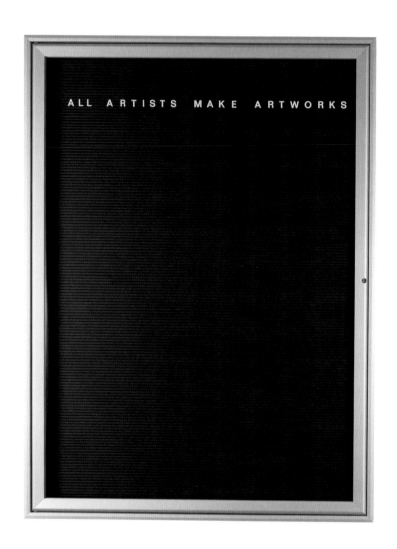

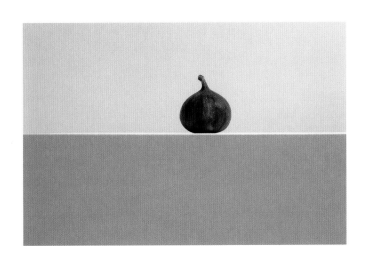

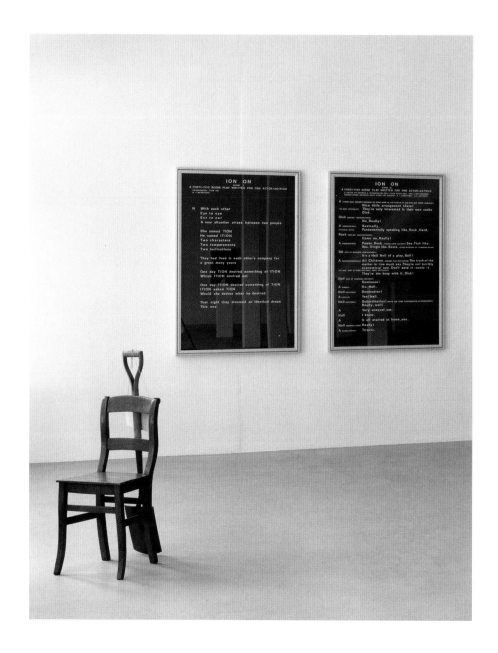

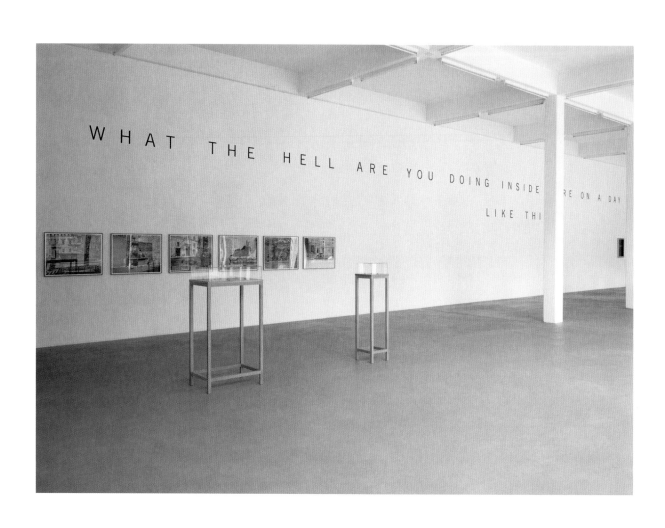

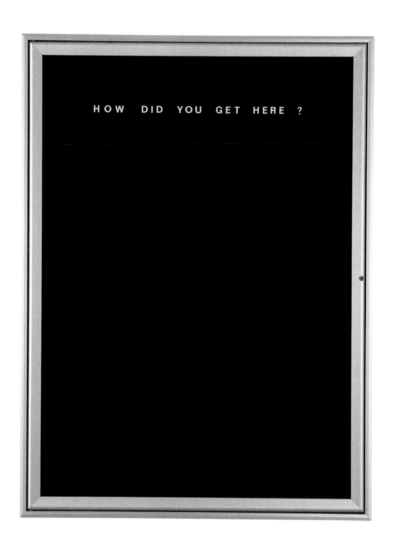

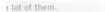a lot of them.

, it's too big. And in any case, there's only one of them.

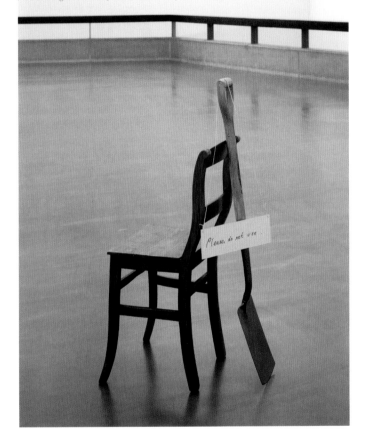

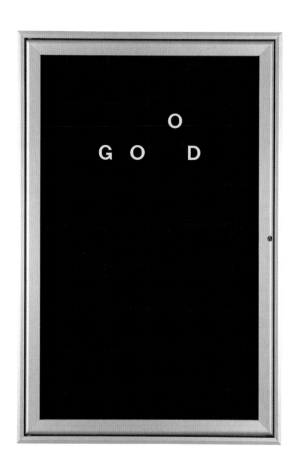

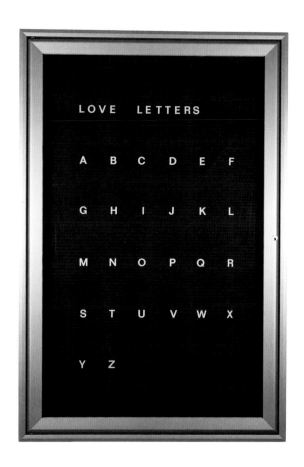

And I sleep

An impulse towards destruction manifests .
Contrary to construction .
Desperation . Isolation . Desolation .
Blocked . Where nothing new for the moment
is constructed.
Of breaking every perceivable object of vision .
Of utter incomprehension .
A complete incapacity to think .
And I sleep in the knowledge that nothing
will have changed when I wake.
And when I wake a great silence answers.

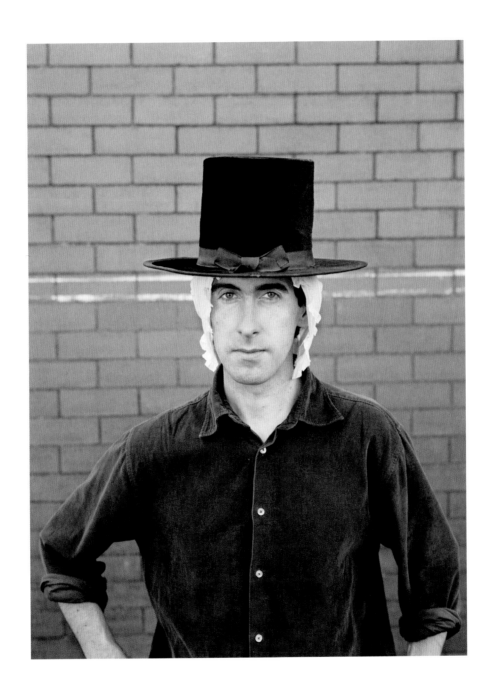

Odyssey: At the base of the brain there is a fountain. *

"Every speech act takes place in a specific physical context, between specific people and to serve a specific function or purpose."

(*Exploring the French Language* by R. Anthony Lodge et al., London 1997, p. 64)

(Wales and the Welsh language)

"'Ga' i weld o?' meddai Begw wrth ei mam a mynd ar ei phennau-gliniau ar gadair yn y tŷ llaeth.

Jeli oedd yr 'o', peth newydd sbon i fam Begw ac i bob mam arall yn yr ardal. I Begw, rhyfeddod oedd y peth hwn a oedd yn ddŵr ar fwrdd y tŷ llaeth yn y nos ac yn gryndod solet yn y bore, ond, yn fwy na hynny, yn beth mor dda i'w fwyta. Neithiwr, yr oedd ei mam wedi gwneud peth coch ar wahân mewn gwydr hirgoes iddi hi ei gael i fynd am de parti i'r mynydd grug efo Mair y drws nesa'. Yr oedd mam Mair am wneud peth iddi hithau, meddai hi. Gobeithiai Begw y cadwai mam Mair ei gair, oblegid mor fawr oedd ei heiddigedd meddiannol o'r jeli fel na fedrai feddwl ei rannu â neb. Yr oedd ei mam wedi deall hynny ac wedi ei wneud ar wahân yn y gwydr del yma.

'Y fi pia hwn i gyd, yntê, Mam?'"

(*Te yn y Grug*, by Kate Roberts, published by Gwasg Gee, Dinbych 1996)

"'Can I see it?' Begw said to her mother going on her hands and knees onto a chair in the dairy.

'It' was a jelly, a brand new thing for Begw's mother and for every mother in the area. For Begw this thing was a marvel that had been water on the dairy table in the night and a quivering solid in the morning, but, more than that, such a good thing to eat. Last night, her mother had made a red one separately in a long-stemmed glass so that she could take it with her to the tea party on the heather mountain with Mair next door. Mair's mother would make one for her, she had said. Begw hoped Mair's mother would keep to her word, so great was her posses-sive envy for the jelly that she could not think to share it with anyone. Her mother had understood that and had made her some separately in this pretty glass.

'It's all mine, isn't it, mother?'"

(*Tea in the Heather*, by Kate Roberts, translated by B. Huws)

*In winter and spring 2005/06 Bethan Huws and Julian Heynen conducted a number of conversations about various aspects of her work which were recorded on tape. In the following months the artist worked intensively on these texts and elaborated on many of her statements and ideas. From the large and unfinished manuscript – a work in progress, so to speak – her dialogue partner has selected a number of passages on important subjects and groups of works to be published in this catalogue. The form of the dialogue has been abandoned for this purpose. (J. H.)

I bought a friend of mine an English translation of another book by Kate Roberts (shows *Traed Mewn Cyffion*). She's Welsh, lived most of her life in Wales but never learnt Welsh. She was my art teacher at school and apparently I'd refused to speak English to her for many years. I bought a copy for myself just to check it out, to see what it was like. When I got it home, I could see that she would never get any profound sense of what it was like. I was simply disappointed 'avec le moral dans les chaussettes, comme on dit en français' (literal translation 'with the moral in the socks'); my heart sank; the wind went out of my sails. I, like Dickens before me, had *Great Expectations*. This is how John Idris Jones opens his translation of the novel: "The hum of insects, gorse crackling, the murmur of heat, and the velvet tones of the preacher endlessly flowing." Now there's only one small problem there: it sounds nothing like the original. I don't even recognise Kate Roberts. Now, I'll read you the original. You don't even have to know Welsh to understand something: "Sŵn pryfed, sŵn eithin yn clecian, sŵn gwres, a llais y pregethwr yn sïo ymlaen yn felfedaidd." You can both see and/or hear the repetition there – "sŵn . . . sŵn . . . sŵn . . ." Now surely that's not just a small detail? There's no such thing as "the hum" or "the murmur" near the original. That's the complete fabrication or invention on the part of the translator, his artistic licence so to speak. Now I'll read you my translation: "Sound of insects, sound of gorse crackling, sound of heat, and the voice of the preacher velvetly murmuring on." That's Kate Roberts, she opens with the word sound, repeats the word two more times, introducing three types of sound and then she suddenly changes to the word voice. I think that's a formidable start to a novel. Now this just makes me think of how many other authors were that badly translated in the past and consequently, their work wasn't given any serious consideration not because of the authors but because of the translators. They must number in their hundreds and thousands by today. How socio-culturally poorer we are consequently.

Many of my father's family came from this area and I visited there a lot when I was growing up. But it's not only that, it's the economy of her language that interests me: she never uses big words and she manages to say a lot to us, she's very precise and clear, almost crystal. She's most often compared to Chekhov. I can't say much there,

I've never read Chekhov. I'll read you what's on the back cover of *Te yn y Grug*.
I've translated it:

> "Several stories about children (but not necessarily for children) living on the
> mountainous slopes of Caernarvonshire [present-day Gwynedd] at the turn of
> the century. These are natural children, narrow in their world, accepting kindness
> and cruelty, cruel and kind in their turn, praying and cursing every second word.
> Through the minds and speech of these children we get a clear and concise
> glimpse of their parents and of other people in this area."

That could be a description of my own and many of my friends' childhoods in rural
Wales, not at the turn of the century but during the sixties and seventies. Wales is so
small that even in the bigger cities you're never that far from the country. When I was
at the British School in Rome and saw all those beautiful things made by the Italians,
spanning two thousand years and more, I strangely thought of Wales and the type of
environment I was brought up in, which is of equal intensity. Wales is much smaller
than Ireland or Scotland; nothing is very far and nothing is very big – it's not unlike a
Chinese garden.

Actually, another thing that made me translate *Te yn y Grug* sooner rather than later
was working with Rhys (Ifans) this summer. At some point, I don't know how far
we'd gone in the filming, Rhys said "Pam wyt ti'n siarad Saesneg hefo fi?" (Why are
you speaking to me in English?). I hadn't even realised that it was English. I'd formu-
lated the whole film script in English and found it incredibly difficult to reformulate it
quickly back into Welsh. I felt very close to him not only because we come from the
same culture, but because we both live and work outside that culture, not because we
want to but because we have no alternative; there's no big city comparable to London
or Paris in Wales. It's a strange and conflicting kind of existence, in our minds we
are still very much in Wales and here we are in exile. That's why I feel close to Beckett
and Joyce, they spent their whole lives thinking/writing about Ireland. I remember
James (Lingwood) telling me when I first moved to Paris, "You're already in exile."
What he hadn't understood is that I'd been in exile for many years in London.

Welsh culture remains largely inaccessible, more so than either Irish or Scottish cultures. Paradoxically, because we still speak and write in Welsh. All our lives and loves are lived out in Welsh and we can't quickly reformulate our thoughts back into English. I remember your remark when we first met: "Your work is not very English." Well, that's because I'm –. The first thing I ever translated was the Haus Esters text. This text only makes full sense to me when I read it back in Welsh. And I learnt several things by doing that. There is no verb 'to have' in Welsh (the first utterance 'which had' kept bothering me). Later, I learn that there is no verb 'to have' in any of the Celtic languages (these people believe that everything is given, that's their spirit). And doesn't this go some way to explain the state of *Wales Today*? And there's no indefinite article 'a / an'. It's either plain 'apple' or 'the apple' in Welsh. The Haus Esters' text is written for the most part in the past tense, third person singular of the verb 'to be' (the existential verb): 'was' (oedd), 'it was' (yr oedd), 'and what was' (a beth oedd). In Welsh the system to answer yes- and no-questions is this: when it's a simple yes/no question it's 'ia-na (ge)', but for the rest we have to repeat each verb in the question with the corresponding tense, person and number: Oedd or yno? (Was he there?) Oedd / Nag oedd (He was / He was not). So each 'was' is a simple and positive affirmation of one's existence and there's a deep sense of agreement with the world there and it has a melancholic touch in that it's a 'yes' spoken in the past, it's reflective. The fact that the words in the Haus Esters text were not my own – I'd chosen these words out of a text spoken by an artist about his work, not mine – seems to have liberated my brain/spirit to think again in Welsh. I ran all the way back home, so to speak. Therefore, my first coat or layer is Welsh, my second is English, and my third is French, and sometimes they move around just like tectonic plates.

(Language)

For this urban project in London the curator asked me to give her some examples of the writings I wanted to use. So I started to translate them into Welsh; also I'm speaking to my partner in Welsh at the moment. If I were to write these texts in Welsh I would do/say exactly the same. If I were to write in French I would do/say exactly

the same. I know that whatever language I would be writing in now, there is a certain spirit which is my own. Some things translate more easily, other less so. *Spot The Dog* (a word vitrine), for example, does not work in either Welsh or French. You'd have to find an equivalent joke that would take more time, or you could simply say: 'Spot Le Chien' or 'Spot Y Ci', but you'd still have to continue to think in English. *The Chocolate Bar* works perfectly well in both these languages 'Le Chocolate Bar', 'Y Siocoled Bar' providing you keep to the original English word order to prepare for the joke at the end. Of course the culture is distinctly British, in that the French don't have thousands of sweets and crisps in newsagents.

Window Frame

"Whatever can be expressed in one language can also be expressed in any other. Provided we allow for a certain amount of 'translation loss' (see Higgins and Hervey 1992), translation from one language to another, no matter how distant their structures are from one another, is always possible. A distinction has been made between the surface structure of language which varies substantially from language to language and a deeper substructure which reflects universal modes of thought. Participation in the latter allows access, with training and experience, to the former."

(*Exploring the French Language*, p. 63)

Window Frame

"On what does the reader base their interpretation of the writer's intended meaning? What is the process of comprehension? We strive to recognise the regularities of discourse structure present in the text. We bring to bear on the text the whole of our resources of sociocultural knowledge. We supply any links missing from the text by making the inferences we consider necessary. The net result is as Yule (1985:112) says: 'Our understanding of what we read does not directly come from what words and sentences are on the page, but from the interpretation we create, in our minds, of what we read.'"

(*Exploring the French Language*, p. 175)

Speaking a foreign language at such an early age made me aware that my language was not the only one. And this is what later led me to study the scientific, not artistic, field of linguistics, a field that's based on observable facts, not fictions. And that so many Welsh people work in the field of language is no accident. My second cousin is a translator and her mother, Mary Hughes, is a novelist and my grandmother also wrote a couple of books on local history. All this happens in Welsh. The state of Switzerland works with four languages. Societies that speak more than one language, that is, which are not monolingual, seem juster societies to me; simply compare Canada to the USA, which is a much more cut and dried system.

(Art school, early works)

When I first went to art school my writings were in Welsh. One day a visiting tutor came and I noticed that he took a much longer time than the others to look through the work (notebooks with writing, photographs and drawings). After some time he proudly said something in Welsh. I was devastated. I stopped writing in Welsh and started to write in English so everyone could read my thoughts. At that precise instant, I abruptly and somewhat brutally became aware 'of an' audience ('ofn' in Welsh is the word for fear), of being watched from right up there in the hills: we're most often betrayed from within. I started to listen to what I'd say.

I think it's Lacan who described the process of analysing a person to that of peeling an onion (and it makes one cry). You take all the layers away one by one until there's nothing left at the end but one's speech: peach, completely naked. That's my first film: the 'cabin' is modelled on a photo booth, the type you find in metro stations all around the world. When we were teenagers, we used to go to Woolworth's and mess around there taking photographs. It was a kind of refuge for me when I first went to college in London. I took many, many photos there, photos of myself and things, a leaf over my eye for example, it was the first thing I did at college. The built 'cabin' comes a bit later and, yes, it takes on the exact dimensions of the photo booth and the only difference is that the walls are transparent or *infra mince* as Duchamp would say. You see through them right to the other end. There is nothing between us and the world.

Later, in 1984, I made a piece in an artists-run studio complex somewhere near Old Street. That was my first exhibition. It was a kind of alphabetisation of some of the materials I found there. I took floor boards up and stacked them to one side in an American Minimalist fashion. Then there was a lot of dust that I collected and arranged somewhere in several piles. It was all very formal and I didn't think much of it. The first thing I was ever satisfied with was the piece at the Royal College of Art, and then I started to do watercolours.

What is consistent is that I intervene minimally with what is there, I asses each situation carefully and propose something accordingly, something that fits or suits both of us (all the 'moulds' of M. Duchamp) where two (to) becomes four (for). There was another thing I did at that time. I had three ruler-like sticks, each a different length and each a different shade of grey. They were the standard widths of wood you buy, which corresponded to the length of a match stick with its end cut off. You see, I smoked even then. These I then glued by eye at regular intervals very much like a guitar neck. The longest corresponded to just below shoulder level and it was the darkest and therefore the thinnest. The mid-shade was waist level. The lightest and the most immaterial was around pubic bone level. I had them for years. I simply looked at them and thought about them, not using them in any other way, like Caderé for example.

(The First Floor)

You could call the floor pieces English-Welsh floors. They are bilingual floors, in fact. In the Welsh language there is 'llawr' which is the word for floor, and there is 'Daear' which is the word for Earth, there's no word for ground, the word 'Daear' doubles up for it when needed. With the floor pieces my thoughts were really in-between the Welsh language and the English language. The choice of words I had in English was playing against the choice of words I had in Welsh. It's difficult to describe. And this prolonged my thinking process.

All works of art are linguistic by nature. Not one of them would exist on Earth without language. All works of art are linguistic constructions. Some are more coherent and others are less coherent, that's certainly true. (Looking at two photographs: 1. a reservoir/dam in Wales, 2. the *Riverside Piece*.) And that's me thinkin', no' me translatin', love. I recognise there (name/identify synonymous paradigm) what I realised here (with the slight 'delay' of Duchamp), inside 'the Big House on the Hill' avec *Eau & Gaz à tous les étages,* the surface-depth antonymous paradigm. Where form (what I'm thinking) and contents (what I'm saying) perfectly correspond or are in total agreement or there is a complete overlap.

In building, constructing, making (slowly realising the floor over a period of a year), there was the notion of ground and/or foundation. One thought I had during the making of the floor, before it appeared in fact, when I first entered the Riverside Studios or even before I entered was this: I wanted to make the equivalent of the *Rush Boat* but in no direct sense. The boat is fundamentally a flat base, a tiny little floor, raft or 'craft' with something sticking up from it (mast). The *Riverside Piece* with someone standing up on it. The Earth and us people sticking up on it and all around it, like a spiky little fruit. I'm thinking of the red Chinese ones or the ones children throw at each other that stick to their clothes. Therefore, the fundamental ground or base or 'floor of the floor' is the *Rush Boat*: the principle model or example (ideal/I-dol) I had followed. Dan Graham often talks of the model in the same way. He and I don't have the same I-dols, that's all. And that's where Manzoni's *Merda d'Artista* comes in. It has to do with facts. Based or founded on fact not fiction, the truth. What is Manzoni's tin of shit founded upon? For him to turn or return and give the art world (field) a tin of human shit, namely his own, artists'. If he gave the art world a tin of shit, that implies to me that what the art world gave him was shit, does it not? Merde! We can only give what we originally received.

Artists don't make works in order to understand them (we understand them, or how else could we make them?) That's logical. We make them based on the assumption that you will equally understand them. Everyone wanted me to continue to do those

floors "go on, another one", and that was what made me suspicious. "Why do they want that?" We like to come to our own conclusions, we don't like others to make them for us. When people do this we can suddenly turn and do the opposite and stop (cause-effect antonymous paradigm). And I'd witnessed a whole generation of artists before me who had made one thing consistently with slight diversifications throughout their careers, and I couldn't see myself doing that, so I tried to find something else.

I came to make the first floor in the simplest way and this has as much to do with my early background, growing up on my parents' farm 'Tai Isa'. My playground was vast, I used to sit for hours and hours on the hills and in the farm. It was a 'paradise' for a child. And I was perfectly aware that this 'heaven' would end. We were given much freedom in this territory.

I knew my ground or territory well. We say in Welsh "Mae pawb yn adnabod ei filltir sgwar" (Each one knows his square mile). My playing field was vast, I knew where the primroses grew, I knew where the snowdrops would grow, I knew where the wren lived, where the fox crossed, where the heron flew. I knew where the cuckoo would sing, where the best blackberries and bilberries grew, I knew where the thickest moss and the smallest grasses grew. I knew where all the briar roses grew. I knew where the ruined cottages were, where the wild cherry tree grew, where the ruined barn was that once belonged to a manor house that had long burnt down. That was my world, or a large part of my world. I knew where to walk in the summer across the fields to the primary school. That's why in part I love Kate Roberts so well. In the simplest and smallest things she finds the world. I spend the best part of my life outdoors. We were only in when it was raining and even then we were often in the barn or in the tool shed. When I went to study to London my feet hurt for a year because they weren't used to walking on concrete, and I'm from Wales not the Amazon.

But coming back or returning to the notion of surface in discussing the floors. That's how you normally see a floor. What was unusual about the floors I'd made is that they equally had depth (surface-depth pair). They were three-dimensional floors.

'Boden / Fussboden' – 'ground / footground' – so that's how one makes the distinction between the ground outside the house and the 'ground' inside the house in German. 'Troedlawr' sounds incredibly poetic in Welsh but then again everything sounds incredibly poetic in Welsh. When we go to the very real detailed, material-substance of things, to what the floor or house is built on, then we've finally reached the foundations and we're finally in the cellar where the bottle racks are kept.

Yes, the word reason, foundation, leads us all to reason, to our final destination, all those fundamental facts on ground level, on the flats, on Earth. The foundation is the last and final step before we reach the ground or the 'rock bottom' of Ludwig Wittgenstein, the end. When there's nothing left to say but to think. And the ground: what makes us depressed is the human. The way some, not all of us, think or function. The why? or The how come? When something doesn't have a good solid ground or base, that is, its foundation at its very beginning, the whole dammed house (construction, architecture) is liable to collapse in the end. There's a joke in *ION ON* this time about the curators' not the artists' constructions: "Trouble is, their shacks are pretty shaky – a bit like jelly."

(*The Lake Writing*)

The response to the work was very different. Everyone had generally been delighted with the floors and then I suddenly changed to words. Half the people who walked into the ICA walked straight out again muttering complainingly to each other "there's nothing to see" (*The Blind Man*). I remember thinking, having witnessed this, "well no, but there's certainly something to read". OK, I agree there was rather a lot to read but there again you weren't obliged to read all of it, you could just take a quick peak, and no one seems to complain that "there is too much to read" in front of a Rembrandt. Why do you think we all became so minimal?

I first realised things inside my head and then carried them out, it's technicians who built the floors, the piece in the RCA. The *Scraped Floor* came about through a particular set of circumstances. I was being pressurised into making a work, otherwise

I would be thrown out of college, and that's what I came up with. I decided to remove the many layers of paint off the floor because that's the only whole thing I had; all the walls differed (parts). I didn't know what Lawrence Weiner had made in 1969. The only difference between the two is the size of the area covered, mine is considerably larger, which reflects my early background/history on the farm. I did that in part because it was all back to carving and casting at the RCA, I thought it would be amusing to carve the floor underneath their feet. It's exactly the same thing/phenomenon as Pierre Huyghe, the sequence of events/syntagma are always past, something we need to follow backwards in time right to the beginning, start or point of origin.

Words refer to things in the world, but equally things in the world refer back to words in our heads. The system is circular (M. Duchamp's wheel). There is the 'word' fountain put in relation to the 'thing' urinal. That's one of the principle keys to understanding *Fountain*.

I also transformed my work into writing because I disagreed with half of what was being said about it and the other half was mostly something I'd said somewhere anyway and was not even credited. I just found it pointless to make a work and then have it all undone by others. I always learnt a lot about the writer.

(Getting to know Duchamp)

At the beginning of my studies at Middlesex the climate was post-Duchamp. The Royal College of Art was conservative, I went to Middlesex because it was considered to be the most radical school in London. It had formerly been Hornsey School of Art and they'd been heavily involved with Paris in 1968. It was anti-everything there – anti-painting, anti-sculpture, anti-drawing. The only thing that was in, was what was called the '4-D' department, all the time-based activities, film, video and performance. But, oddly enough, not once do I remember hearing Duchamp's name. This was an English art school and they were never that hot on art history. It was a very difficult climate to work in; there was very little structure apart from the anti one, we were given very few tools to work with. All you could do was to sit and think.

It was through the work of Robert Gober that I had first heard Duchamp's name. His *Sinks* touched me a lot. I was touched by their hybrid physicality, by what was formulated in them and this was largely due to Ulrich's (Loock) speech. He had talked to me about Gober's work, and I could place his speech into a larger context, in relation to my own and other artists' work, and to some other things he'd said.

I started to think about Duchamp. In 1993 when I began to reflect on what I'd made in Haus Esters, which is what forms the base of *Origin and Source*, his name started to appear more and more. The first time I moved to Paris in 1991 and saw *Fountain* at the Pompidou, it did nothing much to me either, so I know how it feels. I stood there wondering, but there again I'd forgotten to think of it in relation to its title *Fountain*.

I don't think Haus Esters in this instance is a ready-made. Haus Esters remained Haus Esters, that's what I had wanted. With the ready-made, the thing remains recognisably what it is, but also there is a transformation of meaning. Haus Esters wasn't transformed in any way. I proposed a piece of writing because that is what I had wanted and this folded sheet of paper with writing on it you could take home with you, and Haus Esters you could not, that was their relation, two facts.

With *Haus Esters Piece* I had wanted to make the equivalent of an abstract painting in words, that was the model/example I had followed. I first tried to make a work consisting entirely of English prepositions but I failed to make any sense of it and this was when I changed and employed a strategy in order to produce or create a work by asking someone else to speak. The same as I had done in 1991 to produce or create *The Lake Writing* by forcing the words out of my head into a dictaphone.

The origin is the beginning or starting point of something, a headache for example, in this case it's Haus Esters. For the watercolours the starting point can be a shell, a photograph, a dream, a colour, an event, an abstract thought, an art work; for the films, a text . . . The source is always in someone's speech; that's *Fountain*, a constant source of inspiration.

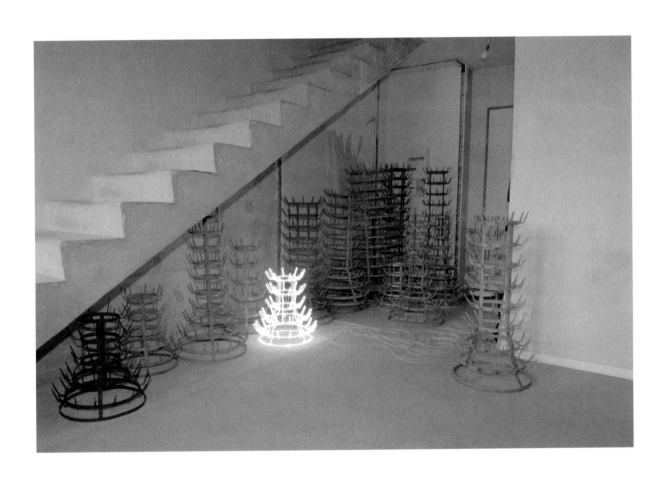

(A pause, after 1993)

I can quite rightly say that the art world – and this is what it can take credit for – had given me cause to a full-blown identity crisis. Not because I didn't know who I was but because they didn't know who I was. It's my profound social nature that made me retreat, like a plant retracts from my hand, and take my distance from the art world, not the other way around.

I started with all that I had by 1993, which was already a lot. I'd worked intensely since 1988, I'd been lucky and I'd always read a lot of philosophy, not that many novels. I started to purely think. By 1993 I had more questions coming in than answers going out. Can you see the problem? And most of these questions weren't even my own. I started to doubt everything, I stopped working intuitively.

I went away from the art world to strengthen my character (frame of reference, paradigm), to build on or to strengthen my walls (house), to better defend my name, who I am, my identity, to make myself some intellectual tools. In early Welsh literature, a literature that reflects a pre-Christian mode of thought, there's a story about a mother who refuses her child three things: 1. she refuses to give her child a name (language), 2. she refuses to give her child arms, 'modern day' tools (culture), 3. she refuses to give her child a wife (love). She's an old cow, basically. Yes, we do have those in Wales as well, they're a universal character. Anyway, his kind Uncle Gwydion finds ways to get him all of these things in turn.

My mother lost her life when she was forty-two. I was then seventeen, from then on I knew the full weight of life and it's the one thing I take seriously. I'm greatly indebted to her. It's the sheer silence of her speech that I remember on the day of her death, the fact that we would never speak to each other again. This thought is principally what structures the film *Singing for the Sea*, the two silent scenes at the beginning and at the end.

(Actors, acting)

Actors are very interesting because they are actually mimicking human behaviour. They observe us, and the more I observe how actors observe people the more I end up observing people more closely too. I was watching this guy on the train the other day. There was a large group of teenagers, including two girls with a baby, the boys were using their affections towards the baby to pick up the girls and vice versa, some great act of flirtation, it was quite comical. Finally, we reach the station and at the very last moment the young mother asks the youngest boy in the group if he would help her off the train with the pram which of course he gladly does. I watched him skip off rather briskly to catch up with the rest of the boys and at that moment his feet were barely touching the ground. I could see that he wanted to shout his joy to us all over the station but he couldn't and it's precisely this failure to communicate or share his joy with us that all of a sudden turns the scene into a tragedy that's most Shakespearean.

Over-reaction or disproportionate behaviour. I saw life for the very first time, a life that was finally not my own. I saw right through the guy to the very end of his bones, to the very fabric of his being. It was incredibly beautiful to watch. I recognised him. It's like Marcel Duchamp's comb – all those subtleties of meaning in-between, the infra thins or the After Eights, fresh. Human beings are imperfect, this is the 'sincerity' of Duchamp. Even when it's misplaced sincerity, it's never the less sincerity, because that was the intention at base. This guys' whole life story unravelled before me, a whole sequence. I use tools to work with, to structure my thoughts with pleasure-pain (antonymous paradigm). You can't understand one without under-standing the other but it's the nuances in-between I'm talking about here.

Actors are the most human of people, contrary to popular belief, husbands' and wives' tales, gossip. To act a truly evil woman or man you have to know its direct opposite (good), that's your base to work from. I'm thinking of Daniel Day Lewis's performance or acting in *Gangs of New York*. A great actor is equally an intellectual.

Well, you can't ask the actor to come to work and then they send the thing by post, can you? The artist, like the actor, is never absent from the work. They're always there before you. I always remember Thierry (Hauch) asking me when we were in college, and it is a very French thing to say: "Does the artwork sleep at night?" Well sometimes it does, sometimes it doesn't. I asked Rhys who is playing in my new film: "How did you come to start acting?" And he said, as a child: "You know, you do your Cowboys and Indians and at teatime you go to tea and stop, but I couldn't." He used to drive his parents mad and play the character all evening long. But his parents must have supported, borne with him somehow. If one or both of his parents had said "Stop that bloody nonsense right or straight away", then Rhys certainly wouldn't be the same Rhys, would he? He makes a very clear distinction, which is something I greatly appreciate, between life and work. He is incredibly professional in that. I've also seen this with other Welsh actors. I think it was Anthony Hopkins, making it perfectly clear to an interviewer that 'it's' his work not his life, acting is what he does: he is not Hannibal Lecter.

Duchamp was playing when he dressed up as a woman for instance. He intentionally circulated the unfounded rumour that it was a woman who was the author of *Fountain*, a rumour that started with what he said in his letter to his sister Susanne.

(Playing)

Playing is the lighter side of life when all the hard work is done. When you have finally mastered language, then you start playing with it. All those word-plays in *ION ON* are purely coincidental, little accidents, none of them were planned, there're all momentary, they simply happen quite naturally when you've gone that far down into your own system, all these levels and layers.

An ironic sense of humour, the same humour you find in *Fountain*, develops when you have finally understood that the system you're in doesn't actually correspond to the one you're on: to life's or natures' given name, that very little makes sense on a grander scale. But you don't give up.

"What did you do this afternoon?

I read a bit of Beckett.

You played a bit of cricket? I didn't know you played cricket.

Neither did I."

(B. H., 2005)

(The Chocolate Bar)

I decided to film *The Chocolate Bar* inside a darkened space without a background. Unlike *ION ON* there is no landscape, nothing to look at other than the actor, the costume. I needed another element to tie in with the principle joke in the text, the joke between Mars the planet and Mars the chocolate bar. I watch a lot of films when I'm preparing for a film. *The Chocolate Bar* is largely inspired by *Coffee and Cigarettes* by Jim Jarmusch. There's a scene 'Jack shows Meg his tesla coil' with all the humorous implications there. This contraption that Jack noisily wheels in is an electrical device that lights up (on) and then short-circuits (off). Because I'd been so preoccupied with Duchamp, it reminded me of one of his earliest ready-mades, the untitled bottle rack. Here, put in combination with light, Man Ray's polarised photographs. The *Bottle Rack* is here because – to use Ulrich's word – it's the 'epitome' of structure. That's what I recognise there, to be realised here. Structures are all those things we do not see, all the behind-the-scenes. A winter tree without its leaves is equally a bare structure or the Eiffel tower. Here's my *Bottle Rack* (shows a Japanese shell with very sharp spikes all around it and positioned vertically as opposed to its original horizontality), where I put the structure back into the system where it came from (which is Duchamp's, not mine or anyone else's). The system is much, much infinitely finer than the structure, the infra thin again, the things we feel deep down inside us and are more difficult to speak about. Lle mae cig mae asgwrn (where there's meat, there's bone). You can't have one without the other.

We don't need to recognise the *Bottle Rack* at all, it can equally be a strange thing standing there in space. Does anyone recognise the costume worn by the actor? It's the Welsh National costume which originated in 17th-century England. After the screening, one would quite naturally ask someone, it might even be a stranger: "What was that strange thing standing there? Was it a chandelier?" And this other someone might know or might not, so unknowingly you've been introduced 1. to Marcel Duchamp and 2. to Welsh culture, and this might make you curious to know more.

Duchamp is from Earth, he had a mother and father like all the rest of us. Duchamp even said somewhere that our parents can be thought of as ready-mades, careful as he was not to say 'his' parents.

The Chocolate Bar (which is an adaptation from an existing text) was a commission from Wales and on this social occasion, and given the context of the Welsh actor, I wanted to introduce another great gentle man to Wales: this time a French man who likewise occasionally dressed up as a woman, both great actors / communicators. It's my gift to Wales.

(Film scripts)

There are hundreds of drawings, perhaps. Some of the drawings have artistic qualities, that's true. Do I consider the preparatory drawings Rembrandt made for his paintings work? Do I separate them out or keep them together? Seeing they are preparatory drawings for a single film, that's something I need to work out. Some of the drawings I analyze, the drawings for *ION ON* and *Fountain* for example. It's often surprising how little information I need to read something as something. They're certainly very different to the watercolours. I learn a lot about the nature of drawing by doing them and some day this will go back into the watercolours.

I first have something in my head, a particular thought or something I see and then I try it out in a drawing, then I add more drawings to this one which forms a whole strip or sequence; a context with backward and forward references just like the sea.

Drawing is relatively fast and cheap to make and filming, especially in 35mm, is extremely expensive. In its edited version *The Chocolate Bar* consists of 25 frames that were filmed over two days. You have to be organised to do film and the less money you have, the more you plan ahead. Even moving heavy equipment around is time-consuming.

What's interesting is that a lot of people from film look at these drawings and they say "Haven't you got a photograph?" They're simply not used to reading drawings. We assume in the art field that everyone's used to reading the world via a drawing, and this is not true.

The basic difference between what an artist does and a filmmaker does is in the frame. In cinema it's a moving frame. To think in a cinematographic sense you have to think in terms of a moving frame, then the changing points of view, camera angles and the potential of cutting in editing. I have to be fast when I'm drawing out a film script. I only put in the quantity of information I need, that is, not too much and not too little. I learn a lot during this process. Sometimes I find that I haven't put enough information or I haven't been precise enough, in capturing the light for instance, information I need for the director of photography. The source material more often than not is from video footage that I've taken on location during the research stage.

(ION ON)

The artist and the curator in *ION ON* are not characters as such in a Shakespearean sense. Characters usually have parents, come from such and such a place, live in such and such a place, have families, and so forth. The figures here have no further identity other than what they are saying, they're pure contents; in this sense they are similar to Beckett's, they are all based on some thought or other, scene 10 is dedicated to Beckett. They're not flesh and blood as such. They're constructions, like bottle racks, something you'll need to figure out. It's then the actor's job to bring them to life.

ION ON started as a play. I had wanted to write a play for a long time, it was somehow always there. It's part of my culture, but it was not until this time that I had enough tools to do so. We used to go to the theatre with our parents when we were young. It's very much part of the Welsh-language communities' scene, small theatres in village and town halls. It's not until the seventies that the bigger state theatres were built. To say, as the English do, that all we do in Wales is sing, is a cliché. The last Welsh-language play I went to see was *Gymerwch chi Sigarèt?* (*Will you have a Cigarette?*) by Saunders Lewis at Theatre Harlech. Saunders Lewis was a contemporary of Kate Roberts. They are to the Welsh what Sartre and de Beauvoir are to the French.

ION ON was initiated from a site-specific project originally intended for the Yorkshire Sculpture Park. I wrote it as a play to be performed in the open air under a huge and magnificent cedar of Lebanon. All the references to the tree in *ION ON* come from there (the tree of life / the state of one's knowledge), by a manor house. The references to 'the Big House on the Hill' in scene 2 come from there and are later worked into the film script by the inclusion of the abandoned mine. All of our thoughts originate somewhere out there in the environment.

By then my interpretation of the site-specific had expanded considerably from my personal experience not only to include the physical but also the social setting, because I had seen that they had profound repercussions on each other. I'd seen my own work – and other artists' work – transformed by curators, and these changes were largely detrimental, not beneficial.

To say what the narrator says in scene 1 of *ION ON* that what follows is TION and ITION's dream, is the same as to say "It's a work of art". Both are linguistic constructions and there's a profound sense of irony there. And from the contents of TION and ITION's dream we can infer that they are both artists.

On one hand some of my watercolours are based on my own dreams, on the other hand there is Freud's *Interpretation of Dreams*. In former times we used to predict the future by reading our dreams, and then there was Martin Luther King's "I have a

dream . . ." which is one of the most unforgettable openings to a speech. Dream, future, vision, paradigm.

There is a dreamlike quality in many of the images in the film. In part that's due to the film stock, it's a Fuji film negative which softens the colour, unlike the Kodak negative. And then there's the location, which is Sardinia and sometimes dreamlike. And the artificial situation of a man dressed in a black suit which is a very formal dress. It's a very dusty environment and his shoes and suit never seem to get dirty, and there is no one else around.

The last scene (45), the horse part, has to be read in the context of an earlier scene (15); it's a back reference. If you miss what was said there about a certain horse named Translation, then you equally miss everything about the horse at the end; it's the same one. The first reference made to a horse is in scene 3, the very last word there. Here the horse is a reference to Freud, to the description Freud made of the human will, which is strong. You have to hold it by the reigns or the mane. There is also an art-historical reference here to the horses of Kounellis. The last scene is a résumé, recapitulation or quick run-through of all the main parts or principle points in *ION ON*. Originally each of these thirteen utterances was to have its own scene.

Window Frame

"Our knowledge of language and of the way in which it has to be adapted to handle particular speech situations forms a major part of our cultural knowledge: 'discourse (and language in general) is a part of culture: because culture is a framework for acting, believing, and understanding, culture is the framework in which communication (and the use of utterances) becomes meaningful' (Schiffrin, 1994:408). This does not mean that all those from a particular culture share exactly the same cultural knowledge. There are large areas of overlap, but our individual cultural knowledge is to an extent personal to us and not the equivalent to a complete member's guide or handbook. [Handbook to accompany *Large Glass* by M. D.] Such knowledge depends, in part at least, on our

personal experience of specific features of our environment, on our education, and on our individual make-up (e.g. our ability to use language, or our capacity to learn and adapt to new circumstances)."

(*Exploring the French Language*, pp. 176–7)

(Odyssey)

If talking/writing like this is an Odyssey, where/what is Ithaca? Home or Ithaca is within the work of art.

Odyssee: Auf dem Grund des Gehirns befindet sich ein Brunnen.*

„Jeder Sprechakt findet in einem bestimmten physischen Kontext zwischen bestimmten Personen und zu einem bestimmten Zweck oder aus einem bestimmten Grund statt."

(Anthony Lodge u. a., *Exploring the French Language*, London 1997, S. 64)

(Wales und das Walisische)

„'Ga' i weld o?' meddai Begw wrth ei mam a mynd ar ei phennau-gliniau ar gadair yn y tŷ llaeth.
Jeli oedd yr 'o', peth newydd sbon i fam Begw ac I bob mam arall yn yr ardal. I Begw, rhyfeddod oedd y peth hwn a oedd yn ddŵr ar fwrdd y tŷ llaeth yn y nos ac yn gryndod solet yn y bore, ond, yn fwy na hynny, yn beth mor dda i'w fwyta. Neithiwr, yr oedd ei mam wedi gwneud peth coch ar wahân mewn gwydr hirgoes iddi hi ei gael i fynd am de parti i'r mynydd grug efo Mair y drws nesa.' Yr oedd mam Mair am wneud peth iddi hithau, meddai hi. Gobeithiai Begw y cadwai mam Mair ei gair, oblegid mor fawr oedd ei heiddigedd meddiannol o'r jeli fel na fedrai feddwl ei rannu â neb. Yr oedd ei mam wedi deall hynny ac wedi ei wneud ar wahân yn y gwydr del yma.
'Y fi pia hwn i gyd, yntê, Mam?'"

(*Te yn y Grug*, by Kate Roberts, published by Gwasg Gee, Dinbych 1996)

„'Darf ich mal sehen?' fragte Begw ihre Mutter, als sie in der Molkerei auf allen Vieren auf einen Stuhl kletterte.
‚Es' war eine Götterspeise, etwas völlig Neues für Begws Mutter wie für jede Mutter in der Gegend.' Für Begw war dieses Ding ein Wunder, das auf dem Tisch der Molkerei in der Nacht noch Wasser gewesen und am Morgen bereits zu einer wabbeligen Masse geworden war, die darüber hinaus auch noch so gut schmeckte. Am Abend zuvor hatte ihre Mutter eine Extraportion in einem langstieligen Glas angerichtet, damit sie diese mit Mair von nebenan zur Teeparty auf dem Heideberg mitnehmen konnte. Mairs Mutter würde ihr auch eine machen, hatte sie gesagt. Begw hoffte, dass Mairs Mutter Wort halten würde, denn ihr Besitzneid auf die Götterspeise, war so groß, dass sie sich nicht vorstellen konnte, sie mit jemand zu teilen. Ihre Mutter hatte das verstanden und ihr eine eigene kleine Portion in diesem hübschen Glas gemacht.
‚Das gehört alles mir, nicht, Mutter?'"

(*Tea in the Heather* by Kate Roberts vom Walisischen ins Englische übersetzt von B. Huws)

*Im Winter und Frühjahr 2005/06 haben Bethan Huws und Julian Heynen mehrere Gespräche über unterschiedliche Aspekte ihrer Arbeit geführt, die auf Band aufgezeichnet wurden. In der Folge hat die Künstlerin intensiv an diesem Text weitergearbeitet und ihre eigenen Statements und Überlegungen ergänzt und erweitert. Aus dem umfangreichen und nicht abgeschlossenen Manuskript, das so entstanden ist, einem ‚work in progress', hat ihr Gesprächspartner einzelne Passagen zu wichtigen Themen und Werkgruppen für den Abdruck in diesem Katalog ausgewählt. Auf die dialogische Form wurde dabei verzichtet. (J. H.)

Ich kaufte einer Freundin einmal die englische Übersetzung eines anderen Buchs von Kate Roberts (*Traed Mewn Cyffion*). Meine Freundin ist Waliserin und lebte die meiste Zeit ihres Lebens in Wales, hat aber nie Walisisch gelernt. Sie war meine Kunstlehrerin, und ich hatte mich Jahre lang bewusst geweigert, englisch mit ihr zu reden. Ich kaufte mir selbst zur Überprüfung auch ein Exemplar. Als ich es zuhause ansah, stellte ich fest, dass sie nie in der Lage sein würde, den tieferen Sinn des Buchs zu erfassen. Ich war schlichtweg enttäuscht ‚avec le moral dans les chaussettes, comme on dit en français‘ (wörtlich übersetzt: ‚mit der Moral in den Socken‘); mir sank das Herz, mir wich der Wind aus den Segeln. Ich hatte, wie vor mir schon Dickens, *Große Erwartungen* gehabt. Die von John Idris Jones vorgenommene Übersetzung des Romans beginnt folgendermaßen: „Das Summen der Insekten, das Geknister des Ginsters, das Murmeln der Hitze und der endlos fließenden samtenen Töne des Predigers." Es gibt da nur ein kleines Problem: Es klingt in keinster Weise wie das Original. Ich erkenne Kate Roberts hier überhaupt nicht wieder. Ich lese jetzt einmal das Original vor. Man muss nicht einmal Walisisch können, um etwas zu verstehen: „Sŵn pryfed, sŵn eithin yn clecian, sŵn gwres, a llais y pregethwr yn sïo ymlaen yn felfedaidd." Man kann die Wiederholung hier sehen und / oder hören – „sŵn . . . sŵn . . . sŵn . . .". Es geht keinesfalls um irgendein unbedeutendes Detail. Im Original ist keine Rede von einem „Summen" oder „Murmeln". Das ist eine reine Fälschung beziehungsweise Erfindung des Übersetzers, seine künstlerische Freiheit sozusagen. Und jetzt lese ich einmal meine Übersetzung vor: „Klang der Insekten, Klang des knackenden Ginsters, Klang der Hitze und die Stimme des samten murmelnden Predigers." Das ist Kate Roberts, sie beginnt mit dem Wort Klang, wiederholt es noch zwei weitere Male und führt drei Arten von Klängen auf, bevor sie plötzlich zum Wort Stimme übergeht. Ich finde, das ist ein eindrucksvoller Romananfang. Das allerdings bringt mir zu Bewusstsein, wie viele andere Autoren in der Vergangenheit ähnlich schlecht übersetzt wurden, deren Werk in der Folge keine ernsthafte Beachtung fand, und zwar nicht aufgrund der Verfasser, sondern aufgrund der Übersetzer. Von ihnen muss es inzwischen Hunderte, wenn nicht Tausende geben. Infolgedessen sind wir soziokulturell gesehen heute um einiges ärmer.

Viele meiner Verwandten väterlicherseits stammten aus derselben Gegend wie Roberts, und als Heranwachsende war auch ich oft dort. Mich interessiert aber darüber hinaus ihre sprachliche Ökonomie: Sie verwendet niemals große Worte, und doch gelingt es ihr, uns etwas mitzuteilen, sie ist äußerst präzise und klar, ja fast kristallin. Man vergleicht sie häufig mit Tschechow. Dazu kann ich nicht viel sagen, weil ich Tschechow nie gelesen habe. Ich werde den Klappentext von *Te yn y Grug* vorlesen, den ich übersetzt habe:

„Verschiedene Geschichten über Kinder (aber nicht unbedingt für Kinder), die zur Zeit der Jahrhundertwende an den Berghängen von Caernarvonshire [dem heutigen Gwynedd] lebten. Es sind Naturkinder, begrenzt in ihrer Welt, die Güte und Grausamkeit erfahren, ihrerseits gütig und grausam sind und mit jedem zweiten Wort Gebete und Flüche ausstoßen. Über die Gedanken und Worte dieser Kinder erhaschen wir einen klaren und prägnanten Blick auf ihre Eltern und andere Menschen aus dieser Gegend."

Dies könnte ebenso gut die Beschreibung meiner eigenen Kindheit und der vieler meiner Freunde im ländlichen Wales sein, nicht während der Jahrhundertwende allerdings, sondern während der sechziger und siebziger Jahre. Wales ist so klein, dass man sich selbst in den größeren Städten in der Nähe des Ländlichen befindet. Als ich in Rom die British School besuchte und all die schönen Dinge sah, die im Laufe von mehr als zweitausend Jahren von den Italienern geschaffen worden waren, musste ich eigenartigerweise an Wales und jenes Milieu denken, in dem ich aufwuchs und das von gleicher Intensität ist. Wales ist wesentlich kleiner als Irland oder Schottland; es gibt keine besonders großen Entfernungen und auch sonst nichts besonders Großes dort – es ist einem chinesischen Garten nicht unähnlich.

Tatsächlich bewegte mich die Zusammenarbeit mit Rhys (Ifans) im letzten Sommer mehr als alles andere zur Übersetzung von *Te yn y Grug*. An einem bestimmten Punkt, ich weiß nicht mehr, wie weit die Dreharbeiten fortgeschritten waren, sagte Rhys: „Pam wyt ti'n siarad Saesneg hefo fi?" (Warum sprichst du Englisch mit mir?) Mir war nicht einmal aufgefallen, dass es Englisch gewesen war. Ich hatte das gesamte Drehbuch in Englisch verfasst und empfand es als äußerst schwierig, es auf die Schnelle zurück ins Walisische zu übertragen. Ich fühlte mich ihm stark verbunden, und zwar nicht nur, weil wir derselben Kultur entstammten, sondern auch, weil wir beide außerhalb dieser Kultur arbeiten, und das nicht, weil wir das so gewollt hätten, sondern weil wir keine Alternative haben, denn in Wales gibt es keine mit London oder Paris vergleichbare Großstadt. Es ist ein eigenartiges, widersprüchliches Leben, mental befinden wir uns immer noch sehr in Wales, während hier unser Exil ist. Aus diesem Grund fühle ich mich wiederum Beckett und Joyce verbunden, die ihr ganzes Leben damit verbrachten, über Irland nachzudenken / zu schreiben. Ich erinnere mich, dass James (Lingwood) mir bei meinem ersten Umzug nach Paris erzählte: „Du befindest dich jetzt im Exil." Er hatte nicht begriffen, dass ich bereits seit vielen Jahren in London im Exil gelebt hatte.

Die walisische Kultur bleibt weitgehend ungreifbar, in stärkerem Maße noch als die irische oder schottische. Das ist paradox, weil wir ja nach wie vor Walisisch sprechen und schreiben. Unser ganzes Leben und Lieben findet auf Walisisch statt, und wir können unsere Gedanken nicht so einfach ins Englische zurückübersetzen. Ich weiß noch, was Julian (Heynen) sagte, als wir uns zum ersten Mal trafen: „Deine Arbeiten sind aber nicht sehr englisch." Na ja, das liegt daran, dass ich es auch nicht bin –. Das erste, was ich jemals übersetzt habe, war der Haus Esters-Text. Dieser Text ergibt nur dann einen vollständigen Sinn, wenn ich in wieder auf Walisisch lese. Und dabei habe ich verschiedenes gelernt. Im Walisischen gibt es nicht das Verb ‚haben' (das erste Wort, das mich in diesem Text stets stört war ‚hatte'). Später erfuhr ich, dass es in keiner der keltischen Sprachen das Wort ‚haben' gibt (diese Menschen glauben, alles sei gegeben, das entspricht ihrem Gemüt). Und lässt sich daraus nicht gewissermaßen der Zustand von *Wales heute* erklären? Weiterhin gibt es keinen unbestimmten Artikel im Walisischen. So heißt es entweder schlicht ‚Apfel' oder aber ‚der Apfel'. Der Text für das Haus Esters wurde zum größten Teil in der Vergangenheits-form der dritten Person Singular des Verbs ‚sein' (auch Seinsverb genannt) verfasst: ‚war' (oedd), ‚es war' (yr oedd), ‚und was war' (a beth oedd). Im Walisischen lautet das System zur Beantwortung von Ja/Nein-Fragen: Wenn es sich um eine einfache Ja/Nein-Frage handelt, heißt es ‚ia-na (ge)', ansonsten aber muss jedes Wort in der Frage mit der entsprechenden Zeit, Person und dem Numerus wiederholt werden: Oedd or yno? (War er da?) Oedd / Nag oedd (Er war/ Er war nicht). Somit ist jedes ‚war' eine einfache, positive Bestätigung der Existenz einer Person, wobei es ein starkes Gefühl der Übereinkunft mit der Welt gibt. Hier liegt eine gewisse Melancholie vor, und zwar insofern, als es um ein in der Vergangenheit ausge-sprochenes, reflektierendes ‚Ja' geht. Die Tatsache, dass es sich bei den Worten des Haus Esters-Textes nicht um meine eigenen handelte – ich hatte sie vielmehr einem Text entnommen, in dem ein Künstler über seine eigene, nicht meine Arbeit spricht – stellte für mich anscheinend eine geistige Befreiung dar, die dazu führte, dass ich wieder Walisisch denken konnte. Ich bin sozusagen den ganzen Weg bis nach Hause zurückgegangen. Insofern ist meine erste Lage oder Hautschicht walisisch, meine zweite englisch und meine dritte französisch, und zuweilen bewegen sich diese gegeneinander wie Kontinentalplatten.

(Sprache)

Für das Projekt im öffentlichen Raum in London bat mich die Kuratorin, ihr einige Beispiele für die Texte zu nennen, die ich verwenden wollte. Daher begann ich, sie ins Walisische zu übersetzen; daneben sprach ich zu dieser Zeit auch mit meinem Partner Walisisch. Wenn ich diese Texte auf Walisisch schreiben

müsste, würde ich exakt dasselbe tun / sagen. Wenn ich auf Französisch schreiben müsste, würde ich exakt dasselbe tun / sagen. Ich weiß, dass, egal in welcher Sprache ich jetzt schreiben würde, es einen bestimmten Geist gibt, welcher der meine ist. Einige Dinge lassen sich leichter übersetzen, andere weniger leicht. *Spot The Dog* (eine Word Vitrine) beispielsweise funktioniert weder im Walisischen noch im Französischen. Man müsste entweder nach einem äquivalenten Witz suchen, was länger dauern würde, oder man könnte einfach sagen: ‚Spot Le Chien‘ beziehungsweise ‚Spot Y Ci‘, wobei man allerdings weiter auf Englisch denken müsste. Die Arbeit *The Chocolate Bar* dagegen funktioniert in beiden Sprachen reibungslos, ‚Le Chocolate Bar‘, ‚Y Siocoled Bar‘, vorausgesetzt, man behält die ursprüngliche englische Wortreihenfolge bei, damit die Pointe am Ende steht. Selbstverständlich geht es hier um eine spezifisch britische Kultur, denn in Frankreich gibt es im Zeitungsladen nicht Tausende Sorten Süßigkeiten und Chips.

Fenster / Rahmen

„Was sich in einer Sprache ausdrücken lässt, lässt sich auch in jeder anderen ausdrücken. Vorausgesetzt, man berücksichtig ein gewisses Maß an ‚Übersetzungsverlust‘ (siehe Higgins und Hervey 1992), so ist die Übersetzung von einer Sprache in eine andere, unabhängig davon, wie unterschiedlich deren Strukturen sind, stets möglich. Dabei wird eine Unterscheidung zwischen der Oberflächenstruktur, die je nach Sprache substanziell variiert, und einer tieferen Substruktur vorgenommen, welche universelle Denkmodi widerspiegelt. Eine Partizipation an letzterer ermöglicht durch Übung und Erfahrung den Zugriff auf erstere."

(*Exploring the French Language*, S. 63)

Fenster / Rahmen

„Worauf gründet der Leser seine Auslegung der beabsichtigten Aussage eines Verfassers? Worin besteht der Verständnisvorgang? Wir streben nach Erkenntnis hinsichtlich der Regelmäßigkeiten der Struktur des im Text vorliegenden Diskurses. Wir lassen in die Behandlung eines Textes unsere gesamten Ressourcen soziokulturellen Wissens mit einfließen. Wir stellen durch als notwendig erachtete Rückschlüsse sämtliche im Text fehlenden Verbindungen her. Das Nettoresultat bezeichnet Yule (1985:112) folgendermaßen: ‚Unsere Deutung des Gelesenen hängt nicht unmittelbar mit den jeweiligen Wörtern und Sätzen auf einer Seite zusammen, sondern mit der geistig vorgenommenen Interpretation des von uns Gelesenen.‘"

(*Exploring the French Language*, S. 175)

Dadurch, dass ich bereits so früh eine Fremdsprache sprach, wurde mir bewusst, dass meine Sprache nicht die einzige war. Und deshalb studierte ich später das nicht künstlerische, sondern wissenschaftliche Fach Linguistik, welches auf beobachtbaren Fakten, nicht auf Fiktionen beruht. Dass so viele Waliser auf dem Gebiet der Sprache arbeiten, ist kein Zufall. Meine zweitälteste Kusine arbeitet als Übersetzerin, ihre Mutter, Mary Hughes, ist Romanautorin, auch meine Großmutter hat einige Bücher über Lokalgeschichte verfasst, und alles das auf Walisisch. In der Schweiz spricht man vier offizielle Sprachen. Gesellschaften, in denen mehr als eine Sprache gesprochen wird, also nicht monolinguale, erscheinen mir als die gerechteren. Man vergleiche nur einmal Kanada und die USA, bei denen es sich um ein wesentlich rigideres System handelt.

(Kunstakademie, frühe Arbeiten)

Als ich anfing, Kunst zu studieren, habe ich noch auf Walisisch geschrieben. Eines Tages kam ein Dozent zur Ansicht meiner Arbeiten. Ich bemerkte, dass er sich wesentlich mehr Zeit nahm als die anderen, um meine Arbeiten (voll geschriebene Notizblöcke, Fotos und Zeichnungen) zu betrachten. Nach einer Weile sagte er stolz etwas auf Walisisch. Ich war erschüttert. Ich hörte auf, Walisisch zu schreiben, und fing an, Englisch zu schreiben, damit jeder meine Gedanken lesen könnte. Ich wurde mir augenblicklich ‚eines‘[1] bestimmten Publikums sowie der Tatsache bewusst, dass ich quasi von den Hügeln aus beobachtet wurde: Zumeist wird man von den eigenen Leuten betrogen. Deshalb fing ich an, darauf zu hören, was ich selbst zu sagen hatte.

Ich glaube, Lacan hat einmal den Prozess der Analyse einer Person mit dem Schälen einer Zwiebel verglichen (und beides ist zum Heulen). Man entfernt nacheinander alle Schichten, bis zum Schluss nichts mehr übrig ist bis auf die eigene Sprache: ausgeliefert und völlig nackt. Darum geht es in meinem ersten Film: Die ‚Kabine‘ entspricht in etwa einem Passbildautomaten, wie man ihn überall auf der Welt in U-Bahnstationen findet. Als wir Teenager waren, gingen wir oft zu Woolworth's, hingen dort ab und machten Passfotos. Das war für mich auch eine Art Flucht, als ich zum ersten Mal in London aufs College ging. Ich habe dort sehr viele Fotos von mir und anderen Motiven gemacht, so etwa mich selbst mit einem Blatt über dem Auge fotografiert; jedenfalls waren es die ersten Arbeiten, die ich auf dem College machte. Die nachgebaute ‚Kabine‘ kam etwas später, und bei ihr hatte ich die exakten Maße des Passbildautomaten übernommen, wobei der einzige Unterschied darin bestand, dass die Wände transparent beziehungsweise

1 Engl. *of an*, Homophon des walisischen Wortes *ofn* (Angst), Anm. d. Ü.

inframince sind, wie Duchamp sagen würde. Man sieht durch sie hindurch bis zur anderen Seite. Es gibt nichts, was zwischen uns und der Welt stünde.

Später, im Jahr 1984, machte ich eine Arbeit in einem von Künstlern betriebenen Atelierkomplex in der Nähe der Old Street. Aus ihr bestand meine erste Ausstellung. Es handelte sich um eine Art Alphabetisierung einiger der von mir dort vorgefundenen Materialien. Ich entfernte die Bodendielen und stapelte sie in der Art der amerikanischen Minimal Art auf einer Seite. Außerdem gab es dort eine Menge Staub, den ich sammelte und irgendwo in mehreren Haufen anordnete. All das war in hohem Maße formal, was mich ein wenig störte. Die Arbeit für das Royal College of Art war die erste, mit der ich zufrieden war, bevor ich begann, Aquarelle zu malen.

Ein durchgängiges Moment meiner Arbeit besteht darin, dass ich nur minimale Eingriffe in das Vorgefundene vornehme, ich schätze jede Situation sorgfältig ein und mache entsprechende Vorschläge, die uns beiden passen (all die ‚Abgüsse' von M. Duchamp), so dass aus zwei vier wird. Zur gleichen Zeit fertigte ich noch eine weitere Arbeit an. Ich hatte drei linealartige Stäbe unterschiedlicher Länge und in verschiedenen Grautönen. Ihre Breite entsprach dem Standardmaß für normal erhältliche Holzleisten und dieses wiederum der Länge eines Streichholzes mit abgeschnittenem Kopf. Du merkst schon, ich habe damals auch schon geraucht. Die Stäbstückchen leimte ich nach Augenmaß in gleichmäßigen Abständen zusammen, so dass sie wie ein Gitarrenhals aussahen. Der längste, dunkelste und schmalste Stab hatte etwas Schulterhöhe. Der Stab in mitteltonigem Grau hatte Hüfthöhe. Der hellste und am stärksten immaterielle Stab entsprach etwa Schambeinhöhe. Ich schleppte sie jahrelang mit mir herum. Ich sah sie nur an und dachte über sie nach, ohne sie zu einem anderen Zweck zu nutzen, wie beispielsweise Caderé.

(Der erste Boden)

Man könnte die Bodenarbeiten als englisch-walisische Böden bezeichnen. Tatsächlich geht es um zweisprachige Böden. Im Walisischen gibt es das Wort ‚llawr' für Fußboden, während das Wort ‚Daear' Erde bedeutet. Es gibt kein eigenes Wort für Boden, dass heißt ‚Daear' hat gegebenenfalls eine Doppelbedeutung. Bei den Bodenarbeiten bewegten sich meine Gedanken wirklich in einem Bereich zwischen der walisischen und der englischen Sprache. Dabei spielte ich meine Wortwahl im Englischen gegen meine Wortwahl im Walisischen; es ist etwas schwer zu beschreiben.

Alle Kunstwerke sind von Natur aus linguistisch. Nicht ein einziges würde ohne Sprache existieren. Bei allen Kunstwerken handelt es sich um linguistische Konstruktionen. Zweifellos sind einige kohärenter als andere (betrachtet zwei Fotos: 1. ein Stausee / eine Talsperre in Wales, 2. das *Riverside Piece*). Und hier denke, nicht übersetze ich, mein Lieber. Ich erkenne (benenne / identifiziere: synonymes Paradigma) dort, was ich hier, im ‚großen Haus auf dem Hügel' *avec Eau & Gaz à tous les étages* (mit der leichten ‚Verspätung Duchamps') erkenne, nämlich das antonyme Paradigma von Oberfläche und Tiefe. Wobei Form (was ich denke) und Inhalt (was ich sage) einander vollkommen entsprechen, in perfekter Übereinstimmung stehen oder sich vollständig überschneiden.

Beim Bauen und Herstellen (und der langsamen Realisierung des Bodens über den Zeitraum eines Jahres) entstand meine Vorstellung von Grund und / oder Fundament. Während der Herstellung des Bodens, bevor er faktisch in Erscheinung trat, beim Betreten der Riverside Studios oder bereits vorher plante ich, ein Äquivalent zu *Rush Boat* zu schaffen, allerdings nicht in einem unmittelbaren Sinne. Bei dem Boot handelt es sich im Grunde um eine flache Platte, einen kleinen Boden, ein Floß oder ‚Schiff', aus dem etwas herausragt (ein Mast). Das *Riverside Piece* mit jemandem, der senkrecht auf ihm steht. Die Erde mit uns Menschen, die überall von ihr abstehen, wie die Stacheln einer kleinen Frucht. Ich denke dabei an diese roten chinesischen Früchte oder an Kletten, mit denen sich Kinder bewerfen und die an ihren Kleidern hängen bleiben. Deshalb ist der fundamentale Grund oder der ‚Boden des Bodens' das *Rush Boat*: das Grundmodell oder -beispiel (Ideal / Idol), nach dem ich mich gerichtet habe. Auch Dan Graham spricht oft in dieser Weise über das Modell. Auch wenn er und ich nicht dieselben Idole haben. Und hier kommt Manzonis *Merda d'Artista* ins Spiel. Es geht um Fakten. Auf der Grundlage oder Basis von Fakten, nicht von Fiktion, auf der Grundlage der Wahrheit. Worauf gründet sich Manzonis Dose mit Scheiße? Für ihn selbst auf einer Umkehrung, darauf, der Kunstwelt eine Dose menschlicher, seiner eigenen beziehungsweise Künstlerscheiße zurückzugeben. Wenn er der Kunstwelt eine Dose mit Scheiße zurückgibt, impliziert das für mich doch, dass das, was er von der Kunstwelt bekam, Scheiße war, oder etwa nicht? Merde! Man kann nur geben, was man ursprünglich einmal bekommen hat.

Künstler bringen nicht Kunstwerke hervor, um diese zu verstehen (wir verstehen sie, wie sollten wir sie sonst machen?) Das ist nur logisch. Wir produzieren sie basierend auf der Annahme, dass ihr sie ebenfalls verstehen werdet. Die Leute wollten, dass ich weiterhin solche Böden machte: „Komm schon, noch einen", und genau das machte mich misstrauisch. „Warum wollen sie das?" Wir ziehen gerne unsere eigenen

Schlüsse und mögen es nicht, wenn das andere für uns tun. Wenn Leute so etwas machen, können wir uns plötzlich umwenden, das Gegenteil tun und aufhören (Ursache-Wirkung: antonymes-Paradigma). Außerdem habe ich miterlebt, wie eine ganze Generation von Künstlern vor mir in ihrer Laufbahn immer wieder eine Sache mit leichten Veränderungen wiederholte, und ich konnte mir nicht vorstellen, es auch so zu machen, deshalb versuchte ich, etwas anderes zu finden.

Ich habe versucht, den ersten Boden auf einfachste Weise herzustellen, was ebenfalls mit meinem biografischen Hintergrund zu tun hat, damit, dass ich auf dem elterlichen Hof ‚Tai Isa' aufgewachsen bin. Ich hatte einen riesigen Spielplatz, ich hielt mich oft stundenlang in den Hügeln und auf dem Hof auf. Es war ein ‚Paradies' für Kinder. Gleichzeitig war mir vollkommen klar, dass dieser ‚Himmel' ein Ende haben würde. Wir hatten dort viele Freiheiten.

Ich kannte mein Terrain beziehungsweise Territorium gut. In Wales sagt man: „Mae pawb yn adnabod ei filltir sgwar" (Jeder kennt seine Quadratmeile). Mein Spielfeld war riesig, ich wusste, wo die Schlüsselblumen wuchsen, ich wusste, wo die Schneeglöckchen wachsen würden, ich wusste, wo der Zaunkönig lebte, wo der Fuchs lief, wo der Reiher flog. Ich wusste, wo der Kuckuck singen würde, wo die besten Brombeeren und Blaubeeren wuchsen, ich wusste, wo die dichtesten Moose und die feinsten Gräser wuchsen. Ich wusste, wo all die Wildrosen wuchsen. Ich wusste, wo die Landhausruinen standen, wo der Wildkirschbaum wuchs, wo die verfallene Scheune stand, die einst zu einem längst abgebrannten Herrenhaus gehört hatte. Das war meine Welt oder ein großer Teil meiner Welt. Ich wusste, wie ich im Sommer durch die Felder zur Grundschule kam. Darum zum Teil liebe ich Kate Roberts so sehr. Sie erkennt die Welt in den einfachsten und kleinsten Dingen. Ich habe die beste Zeit meines Lebens draußen verbracht. Drinnen waren wir nur, wenn es regnete, und selbst dann hielten wir uns oft in der Scheune oder im Geräteschuppen auf. Als ich zum Studieren nach London zog, taten mir ein Jahr lang die Füße weh, weil ich es nicht gewohnt war, auf Beton zu laufen, und ich komme aus Wales, nicht vom Amazonas.

Um aber bei der Beschreibung der Böden auf den Begriff der Oberfläche zurückzukommen: Man nimmt einen Fußboden in der Regel ‚oberflächlich' wahr. Das Ungewöhnliche an den von mir gemachten Böden liegt darin, dass sie gleichermaßen Tiefe besaßen (Oberfläche / Tiefe-Paar). Es handelt sich bei ihnen um dreidimensionale Böden. ‚Boden / Fußboden' – so unterscheidet man im Deutschen zwischen dem Boden im Freien und dem Boden im Haus. ‚Troedlawr' klingt im Walisischen unglaublich poetisch, allerdings klingt ja alles im Walisischen unglaublich poetisch. Wenn wir die tatsächliche materielle Substanz der

Dinge betrachten, das, auf dem der Boden oder das Haus errichtet wurde, so sind wir endlich bei den Fundamenten angelangt und befinden uns im Keller, wo auch die Flaschentrockner stehen.

Ja, das Wort Grund[2], Fundament, führt uns zum reinen Grund, zu unserem endgültigen Bestimmungsort, all jenen fundamentalen Tatsachen in Bodenhöhe, auf der Ebene, auf der Erde. Das Fundament bildet den letzten und endgültigen Schritt, bevor wir den Boden oder tiefsten Punkt Ludwig Wittgensteins und damit das Ende erreichen. Den Ort, an dem sich nichts mehr sagen oder denken lässt. Und dieser Boden, das was uns deprimiert, ist das Menschliche. Die Art und Weise, wie einige, nicht alle, denken und funktionieren. Das „Warum?" oder „Weshalb?". Verfügt etwas nicht über einen festen Boden, das heißt ein Fundament für seinen Ansatz, so kann das ganze Haus (Bau, Architektur) zum Schluss zusammenstürzen. Es gibt in meinem neuen Film *ION ON* einen Witz über die Bauten der Kuratoren, nicht der Künstler: „Das Problem ist, ihre Buden sind ziemlich wackelig – ein bisschen wie Götterspeise."

(*The Lake Writing*)

Die Reaktion auf diese Arbeit fiel völlig anders aus. Im Allgemeinen waren alle von den Böden entzückt gewesen, und jetzt arbeitete ich plötzlich mit Wörtern. Die Hälfte der Leute, die ins ICA kamen, ging gleich wieder und monierte, dass „es nichts zu sehen gab" (*The Blind Man*). Ich weiß noch, als ich das merkte, dachte ich: „Na, gut, aber immerhin gibt es etwas zu lesen." Okay, es stimmt schon, es ziemlich viel zu lesen, aber schließlich war man ja nicht verpflichtet, alles zu lesen, man konnte auch nur einen kurzen Blick darauf werfen. Außerdem beklagt sich doch auch niemand vor einem Rembrandt darüber, dass „es zuviel zu lesen" gäbe. Warum sind wir wohl alle derart minimalistisch geworden?

Ich habe die Dinge zunächst im Kopf realisiert und sie anschließend ausgeführt. Den Boden fürs Royal College of Art ließ ich von Fachleuten einziehen. *Scraped Floor* entstand als Reaktion auf bestimmte Umstände. Man setzte mich unter Druck, eine Arbeit abzuliefern, ansonsten flöge ich vom College, und so lieferte ich diese Arbeit ab. Ich entschloss mich, die unzähligen Farbschichten auf dem Boden zu entfernen, weil dieser das einzig Einheitliche dort war, denn die Wände (Teile) unterschieden sich alle voneinander. Ich wusste damals noch nicht, was Lawrence Weiner 1969 gemacht hatte. Der einzige Unterschied zwischen meiner und seiner Arbeit besteht darin, dass bei mir die behandelte Fläche wesentlich größer ist, was meinen frühen Background/meine Bauernhofvergangenheit widerspiegelt. Ich relisierte diese Arbeit unter anderem, weil am Royal College of Art wieder einmal nur bildhauerisch gearbeitet, geschnitzt und

2 Engl. *reason*, Anm. d. Ü.

gegossen wurde, und so dachte ich, es wäre amüsant, ihnen den Boden unter den Füßen wegzukratzen. Das ist dasselbe (Phänomen) wie bei Pierre Huyghe, die Abfolge von Ereignissen / Syntagmen ist stets vergangen und muss in zeitlich umgekehrter Reihenfolge bis zum Beginn, Anfang oder Ursprung zurückverfolgt werden.

Wörter verweisen auf Dinge in der Welt, und umgekehrt verweisen auch Dinge in der Welt zurück auf Wörter in unseren Köpfen. Das System ist zyklisch (M. Duchamps Rad). Das ‚Wort‘ Fontäne wird in eine Relation gesetzt zum ‚Gegenstand‘ Urinal. Das ist einer der Grundschlüssel zum Verständnis von *Fontaine*.

Ich bin auch in meinen Arbeiten zum Schreiben übergegangen, da ich mit der Hälfte dessen, was über sie gesagt wurde, nicht einverstanden war, wobei es sich bei der anderen Hälfte um Dinge handelte, die ich selbst einmal irgendwo gesagt hatte, die aber nicht einmal als Zitat ausgewiesen wurden. Ich fand es einfach witzlos, eine Arbeit zu machen und sie dann von anderen wieder auflösen zu lassen. Dabei habe ich allerdings immer viel über den Verfasser gelernt.

(Duchamp verstehen lernen)

Zu Beginn meines Studiums am Middlesex Politechnic herrschte ein post-Duchamp-Klima vor. Das Royal College of Art war konservativ, und ich ging nach Middlesex, weil man sagte, das sei die radikalste Schule in London. Ich hatte zuvor an der Hornsey School of Art studiert und mich intensiv mit dem Thema Paris 1968 beschäftigt. Es gab dort eine grundlegende Antihaltung – gegen Malerei, gegen Skulptur, gegen Zeichnen. Lediglich der so genannte ‚4-D‘-Fachbereich galt als hip, also alle zeitabhängigen Aktivitäten wie Film, Video und Performance. Allerdings erinnere ich mich seltsamerweise nicht, dort jemals den Namen Duchamp gehört zu haben. Es war ja eine englische Akademie, und dort war man nie allzu versessen auf Kunstgeschichte. Es herrschte ein sehr schwieriges Arbeitsklima; sehr unstrukturiert, einmal abgesehen von der Anti-Struktur. Uns wurden sehr wenig Arbeitsmittel zur Verfügung gestellt. Alles, was man tun konnte, war Herumsitzen und Nachdenken.

Über die Arbeit von Robert Gober stieß ich erstmals auf den Namen Duchamp. Seine *Sinks* haben mich sehr beeindruckt. Mich berührte ihre zwitterhafte Körperlichkeit, das, was in ihnen formuliert wurde, und zwar in erster Linie dank des von Ulrich (Loock) Gesagten. Er hatte mit mir über Gobers Werk gesprochen, und ich konnte dies in einen umfassenderen Kontext, auf sein Verhältnis zu meiner Arbeit und zur Arbeit anderer Künstler sowie auf andere Dinge, die er gesagt hatte, übertragen.

Ich fing an, über Duchamp nachzudenken. Als ich 1993 begann zu reflektieren, was ich für das Haus Esters gemacht hatte, was schließlich die Grundlage für *Origin and Source* wurde, tauchte sein Name erstmals wieder häufiger auf. Als ich 1991 zum ersten Mal nach Paris ging und *Fontaine* im Pompidou sah, löste das bei mir auch noch nichts aus, ich kenne dieses Gefühl also. Ich stand da und wunderte mich, andererseits hatte ich versäumt, über das Verhältnis dieser Arbeit zum Titel *Fontaine* nachzudenken.

Ich finde nicht, dass es sich im Fall von Haus Esters um ein Readymade handelt. Das Haus Esters blieb das Haus Esters, so hatte ich es gewollt. Beim Readymade bleibt zwar erkennbar, was es ist, aber es findet auch eine Bedeutungstransformation statt. Das Haus Esters wurde in keinster Weise transformiert. Ich schlug einen Text vor, weil ich es gewollt hatte, und dieses gefaltete Textblatt konnte man im Gegensatz zum Haus Esters mit nach Hause nehmen. Darin, in diesen beiden Tatsachen, bestand ihre Beziehung zueinander.

Bei *Haus Esters Piece* wollte ich mit Hilfe von Wörtern ein Äquivalent zu einem abstrakten Bild schaffen. Nach diesem Modell / Beispiel bin ich vorgegangen. Zunächst versuchte ich, ein Wort zu schaffen, das ausschließlich aus englischen Präpositionen bestand, aber es gelang mir nicht, ihm einen Sinn zu geben, und so überlegte ich es mir anders und entwarf eine Strategie zur Produktion oder Herstellung eines Kunstwerks, indem ich jemand anders darum bat zu sprechen. Das war dieselbe Vorgehensweise wie im Jahr 1991, als ich *The Lake Writing* produzierte, indem ich die Wörter aus meinem Kopf herauspresste und in ein Diktaphon sprach.

Am Beginn steht irgendein Auslöser für etwas, beispielsweise ein Kopfschmerz, und in diesem Fall ist es das Haus Esters. Der Anfangspunkt für die Aquarelle kann eine Muschel sein, ein Foto, ein Traum, eine Farbe, ein Ereignis, ein abstrakter Gedanke, ein Kunstwerk. Bei den Filmen kann es beispielsweise ein Text sein. Der Ursprung liegt immer im Sprechen von jemandem. Das bedeutet *Fontaine*: eine nicht versiegende Quelle der Inspiration.

(Ein Interval nach 1993)

Ich kann mit einigem Recht sagen, dass die Kunstwelt – und das kann sie sich als Verdienst anrechnen – mir den Anlass zu einer ausgewachsenen Identitätskrise lieferte. Nicht etwa, weil ich nicht wusste, wer ich war, sondern weil sie nicht wussten, wer ich war. Aufgrund meines ausgeprägten sozialen Wesens musste ich mich zurückziehen, so wie eine Pflanze sich bei Berührung zurückzieht, und mich von der Kunstwelt distanzieren, nicht umgekehrt.

Das alles fing 1993 an und betraf alles bisher Erreichte, was bereits eine ganze Menge war. Ich hatte seit 1988 intensiv gearbeitet und glücklicherweise viel Philosophie und nicht allzu viele Romane gelesen. So fing ich an, mich dem reinen Denken zu widmen. Um 1993 herum stellte ich mehr Fragen, als ich Antworten gab. Verstehst du das Problem? Und bei den meisten dieser Fragen handelte es sich nicht einmal um meine eigenen. Ich fing an, alles anzuzweifeln, und hörte intuitiv auf zu arbeiten.

Ich habe mich von der Kunstwelt abgewendet, um meinen Charakter zu festigen (Bezugsrahmen, Paradigma), um meine Mauern aufzubauen beziehungsweise zu verstärken (Haus), meinen Namen und meine Identität besser zu verteidigen und mir ein intellektuelles Instrumentarium zu schaffen. In der frühen walisischen Literatur, die eine vorchristliche Denkweise reflektiert, gibt es eine Geschichte von einer Mutter, die ihrem Sohn drei Dinge verweigert: 1. Sie verweigert ihm einen Namen (Sprache), 2. Sie verweigert ihm Waffen, ‚moderne' Werkzeuge (Kultur), 3. Sie verweigert ihm eine Frau (Liebe). Sie ist im Grunde eine dumme Kuh. Ja, davon gibt es auch in Wales welche, das ist ein universeller Charakter. Jedenfalls findet sein guter Onkel Gwydion Mittel und Wege, ihm seinerseits zu all diesen Dingen zu verhelfen.

Meine Mutter starb im Alter von 42 Jahren. Ich war damals siebzehn, und von da an wusste ich um die volle Last des Lebens, etwas, das eine wichtige Rolle für mich spielt. Dafür bin ich ihr zu tiefem Dank verpflichtet. Ich erinnere mich gut an ihr Schweigen am Tag ihres Todes, an die Tatsache, dass wir nie wieder miteinander reden würden. Dieser Gedanke gibt im Prinzip die Struktur des Films *Singing for the Sea*, der beiden stummen Szenen am Anfang und am Ende, vor.

(Schauspieler, Schauspielerei)

Schauspieler sind deshalb so interessant, weil sie im eigentlichen Sinne menschliches Verhalten imitieren. Sie beobachten uns, und je mehr ich beobachte, wie Schauspieler Menschen beobachten, desto mehr gehe ich dazu über, die Menschen ebenfalls genauer zu beobachten. Ich beobachtete beispielsweise einmal einen Typ im Zug. Da gab es eine große Gruppe Teenager, unter ihnen zwei Mädchen mit einem Baby, und die Jungs nutzten ihre Zuneigung gegenüber dem Baby, um die Mädchen anzumachen und umgekehrt. Das war ein toller Flirt, ziemlich komisch. Schließlich erreichen wir die Haltestelle, und im allerletzten Moment fragt die junge Mutter den jüngsten Kerl aus der Gruppe, ob er ihr mit dem Kinderwagen helfen könne, was er natürlich gerne tat. Ich beobachtete, wie er plötzlich einen Satz machte, um die anderen Jungen wieder einzuholen, und in diesem Moment berührten seine Füße kaum den Boden. Ich konnte genau

sehen, dass er uns allen seine Freude an der Haltestelle entgegenrufen wollte, es aber nicht konnte, und genau dieses Versagen, zu kommunizieren oder seine Freude mit uns zu teilen, verwandelte die Szene plötzlich in eine Tragödie von fast Shakespeare'schen Ausmaßen.

Überreaktionen und unangemessenes Verhalten. Zum ersten Mal erkannte ich das Leben, ein Leben, das letztlich nicht meins war. Ich durchschaute den Kerl geradezu bis auf die Knochen, bis auf die Fasern seines Seins. Es war wunderschön anzusehen. Ich erkannte ihn. Es war wie Marcel Duchamps Kamm – all jene Bedeutungssubtilitäten dazwischen, die Infrathins oder frischen After Eights. Menschen sind unvollkommen, darin liegt Duchamps Ernsthaftigkeit. Auch wenn diese Ernsthaftigkeit deplaziert wirkt, so ist es doch eine ‚Ernsthaftigkeit‘, denn das war die zugrunde liegende Absicht. Die ganze Lebensgeschichte des Jungen in seiner gesamten Abfolge entwirrte sich vor meinen Augen. Ich nutze bei meiner Arbeit Hilfsmittel, um meine Gedanken durch Freude/Leid (antonymes Paradigma) zu strukturieren. Man kann das eine nicht ohne das andere verstehen, aber ich spreche hier von den Nuancen zwischen beiden.

Entgegen allen landläufigen Annahmen, dem Gerede und dem Klatsch von Ehefrauen und -männern sind Schauspieler die menschlichsten Menschen. Um eine böse Frau oder einen bösen Mann spielen zu können, muss man deren beziehungsweise dessen direktes Gegenteil kennen, (das Gute); das ist die Arbeitsgrundlage des Schauspielers. Ich denke hier beispielsweise an Daniel Day Lewis' Darstellung in *Gangs of New York*. Ein guter Schauspieler ist immer auch ein Intellektueller.

Man kann wohl kaum einen Schauspieler engagieren und seine Arbeit dann per Post versenden, nicht wahr?
Der Künstler ist genau wie der Schauspieler immer in seiner Arbeit gegenwärtig. Beide sind immer schon vor einem da. Ich erinnere mich daran, wie Thierry (Hauch) mich während unserer Akademiezeit fragte, und das ist übrigens typisch französisch: „Schläft das Kunstwerk nachts?" Na ja, manchmal schon, manchmal nicht. Ich fragte Rhys, der in meinem neuen Film mitspielt: „Wie bist du dazu gekommen, mit der Schauspielerei anzufangen?" Und er sagte, der Entschluss sei während seiner Kindheit gereift: „Weißt du, man spielt Cowboy und Indianer, und zum Tee geht man nach Hause und hört damit auf, aber ich konnte nicht aufhören." Er hat seine Eltern damals in den Wahnsinn getrieben, indem er seine Rolle den ganzen Abend weiterspielte. Allerdings müssen seine Eltern irgendwie Nachsicht mit ihm gehabt, ja ihn sogar unterstützt haben. Hätten ein oder beide Elternteile gesagt: „Hör sofort mit dem Blödsinn auf", dann wäre Rhys heute sicher nicht derselbe Rhys, oder? Er kann sehr deutlich zwischen Leben und Arbeit

unterscheiden, und das schätze ich sehr an ihm. In dieser Hinsicht ist er extrem professionell. Das habe ich auch bei anderen walisischen Schauspielern beobachtet. Ich glaube, Anthony Hopkins erklärte einmal in einem Interview, dass ‚es' seine Arbeit und nicht sein Leben sei. Er sei Schauspieler, nicht Hannibal Lecter.

Duchamp spielte beispielsweise eine Rolle, als er sich als Frau verkleidete. Er streute bewusst das unbegründete Gerücht, die *Fontaine* sei von einer Frau hervorgebracht worden. Dieses Gerücht nahm seinen Anfang in einem Brief, den er an seine Schwester Susanne geschrieben hatte.

(Spielen)

Das Spiel ist die leichtere Hälfte des Lebens, nachdem die Arbeit erledigt ist. Wenn man die Sprache endlich beherrscht, beginnt man, mit ihr zu spielen. Diese ganzen Sprachspiele in *ION ON* entstanden rein zufällig, es waren kleine Pannen, keins von ihnen war geplant, alle ereigneten sich spontan. Sie kommen ganz von selbst, sobald man sich derart tief in das eigene System mit all seinen Ebenen und Schichten hineinbegibt.

Ein gewisser Sinn für Ironie, derselbe Humor, der sich auch in der *Fontaine* findet, entsteht, wenn man schließlich erkennt, dass das System, in dem man sich selbst befindet, sich keineswegs mit dem System deckt, über das man spricht: Im Hinblick auf Begriffe wie Leben oder Natur sagt das im großen Ganzen zwar wenig aus. Trotzdem gibt man nicht auf.

„Was hast du heute Nachmittag gemacht?

Ich habe mich ein bisschen mit Beckett beschäftigt.

Du hast dich ein bisschen mit Cricket beschäftigt? Ich wusste gar nicht, dass du Cricket spielst.

Das wusste ich auch nicht."

(B. H., 2005)

(The Chocolate Bar)

Ich entschied mich, den Film *The Chocolate Bar* in einem abgedunkelten Raum ohne einen Hintergrund zu drehen. Anders als bei *ION ON* gibt es hier keine Landschaft, nichts außer dem Schauspieler und seinem Kostüm, was sich betrachten ließe. Ich brauchte ein anderes Element, mit dem ich an den grundsätzlichen Witz im Text, den Witz, der auf dem Planeten Mars und dem Schokoriegel Mars beruhte, anknüpfen konnte. Wenn ich einen Film vorbereite, sehe ich mir eine Menge anderer Filme an. *The Chocolate Bar* ist in hohem Maße durch *Coffee and Cigarettes* von Jim Jarmusch beeinflusst. Es gibt darin die Szene ‚Jack shows Meg his tesla coil' (Jack zeigt Meg seine Teslaspule) mit allerlei humoristischen Implikationen. Bei dieser von Jack geräuschvoll herangekarrte Vorrichtung handelt es sich um eine elektrische Apparatur, die zunächst aufleuchtet (an) und dann einen Kurzschluss auslöst (aus). Da ich so zwanghaft mit Duchamp beschäftig gewesen war, erinnerte mich das Gerät an eines seiner frühesten Readymades, den Flaschentrockner. In diesem Falle, in Verbindung mit Licht, an Man Rays polarisierte Fotografien. Wir treffen im Film den Flaschentrockner an, weil es sich bei ihm – um Ulrichs Worte zu benutzen – um den ‚Inbegriff' von Struktur handelt. Was ich dort erkenne, muss ich hier verwirklichen. Strukturen sind all jene Dinge hinter den Kulissen, die man nicht sieht, die Hintergründe. Ein blattloser winterlicher Baum stellt ebenso eine Grundstruktur dar wie der Eiffelturm. Hier siehst du meinen Flaschentrockner (zeigt eine japanische Muschel mit umlaufenden spitzen Stacheln, die entgegen ihrer ursprünglich horizontalen Ausrichtung vertikal aufgestellt ist), bei dem ich die Struktur zurück auf das System übertrug, dem sie angehört (nämlich Duchamps System, nicht meines oder das von jemand anders). Das System ist unendlich feiner als die Struktur, also wieder das Infrathin, das, was wir tief in uns spüren und mit dem wir größere Schwierigkeiten haben. Lle mae cig mae asgwrn (Wo Fleisch ist, sind auch Knochen). Man kann das eine nicht ohne das andere haben.

Man muss den *Flaschentrockner* im Film mitnichten erkennen, es kann sich hier genauso gut um irgendeinen anderen eigenartigen, im Raum herumstehenden Gegenstand handeln. Erkennt vielleicht irgendjemand das Kostüm des Schauspielers wieder? Es handelt sich um die walisische Nationaltracht, deren Ursprung im England des 17. Jahrhunderts liegt. Nach der Vorführung konnte man ganz selbstverständlich jemanden, selbst einen Wildfremden, fragen: „Was war das für ein komisches Ding, das hier stand? War das ein Lüster?" Und jener hätte es unter Umständen gewusst, so dass man unbewusst 1. mit Marcel Duchamp und 2. mit der walisischen Kultur Bekanntschaft gemacht hätte und vielleicht neugierig geworden wäre, mehr darüber zu erfahren.

Duchamp stammt von der Erde, er hatte wie alle von uns Mutter und Vater. Duchamp sagte sogar irgendwo einmal, dass man die eigenen Eltern als Readymades betrachten könne, und er war vorsichtig genug, dabei nicht von ‚seinen' Eltern zu sprechen.

The Chocolate Bar (die Adaption eines vorhandenen Textes) war eine Auftragsarbeit für Wales, und zu diesem gesellschaftlichen Zweck sowie angesichts des Kontextes eines walisischen Schauspielers wollte ich Wales noch einen weiteren großen, behutsamen Mann (gentle man) vorstellen, diesmal einen Franzosen, der sich ebenfalls gelegentlich als Frau verkleidete, beides große Schauspieler / Kommunikatoren. Das ist mein Geschenk an Wales.

(Filmskripts)

Es gibt womöglich Hunderte von Zeichnungen. Einige dieser Zeichnungen verfügen tatsächlich über einen künstlerischen Wert. Betrachte ich die Zeichnungen, die Rembrandt als Vorarbeiten für seine Gemälde anfertigte, als eigenständige Kunstwerke? Separiere ich diese, oder behandele ich sie als eine Ganzheit? In Anbetracht der Tatsache, dass es sich um Skizzen für einen Film handelt, muss ich dieser Frage Rechnung tragen. Das gilt beispielsweise für einige der von mir analysierten Zeichnungen für *ION ON* und *Fountain*. Oft überrascht es, wie wenige Informationen man braucht, um etwas als etwas lesen zu können. Zweifellos unterscheiden die Zeichnungen sich deutlich von den Aquarellen. Ich habe durch sie eine Menge über das Wesen der Zeichnung gelernt, und dieses Wissen wird eines Tages wiederum in die Aquarelle einfließen.

Ich gehe zunächst von einem bestimmten Gedanken oder von etwas aus, das ich vor Augen habe und dann in einer Zeichnung erprobe, anschließend füge ich dieser weitere Zeichnungen hinzu, bis eine ganze Reihe oder Sequenz entsteht, ein Kontext mit Vor- und Rückverweisen, wie beim Meer. Zeichnungen lassen sich relativ schnell und preiswert herstellen, während ein Film, gerade im Format 35 mm, extrem kosten-aufwändig ist. In der bearbeiteten Fassung besteht *The Chocolate Bar* aus 25 Frames, die im Verlauf von zwei Tagen gefilmt wurden. Man muss geordnet vorgehen, wenn man einen Film produziert, und je weniger Geld zur Verfügung steht, desto weiter muss man vorausplanen. Selbst das Herumwuchten von schweren Geräten nimmt ja sehr viel Zeit in Anspruch.

Es ist interessant, dass sich viele Filmmenschen diese Zeichnungen ansehen und dann fragen: „Hast du kein Foto davon?" Sie sind es einfach nicht gewohnt, Zeichnungen zu lesen. In der Kunstwelt gehen wir davon

aus, dass jeder damit vertraut ist, die Welt über eine Zeichnung vermittelt wahrzunehmen, aber das stimmt nicht.

Der grundlegende Unterschied zwischen der Vorgehensweise eines bildenden Künstlers und eines Filmemachers betrifft das Einzelbild. Beim Kino geht es um ein bewegtes Bild. Wenn man filmisch denkt, muss man im Sinne eines bewegten Bildes, wechselnder Perspektiven und Kameraeinstellungen sowie des späteren Filmschnitts denken. Beim Verfassen eines Skripts muss ich schnell sein. Ich liefere lediglich die unbedingt notwendigen Informationen, nicht mehr und nicht weniger. Bei diesem Prozess lernt man sehr viel dazu. Manchmal merke ich, dass ich zu wenige Angaben gemacht habe, wenn ich beispielsweise bei der Belichtung, also bei Informationen, die ich für den Kameramann benötige, ungenau war. Zumeist verwende ich als Ausgangsmaterial Videoaufnahmen, die ich vor Ort während der Recherchephase gemacht habe.

(*ION ON*)

In *ION ON* sind Künstler und Kurator keine Figuren im Shakespeare'schen Sinne. Solche Figuren haben in der Regel Eltern, kommen von einem bestimmten Ort, leben an einem bestimmten Ort, haben eine Familie und so fort. Meine Figuren verfügen über keine Identität, die über das von ihnen Gesagte hinausreicht, sie sind reiner Inhalt; in dieser Hinsicht ähneln sie Becketts Figuren. Sie alle basieren auf einem bestimmten Gedanken. Szene 10 ist übrigens Beckett gewidmet. Es sind keine Figuren aus Fleisch und Blut, sondern Konstruktionen wie Flaschentrockner, etwas zum Verständnis Notwendiges. Die Aufgabe des Schauspielers liegt folglich darin, diese Konstruktionen mit Leben zu füllen.

ION ON war ursprünglich ein Theaterstück. Ich hatte schon lange ein Stück schreiben wollen, denn so etwas war immer schon in mir. Theater ist Teil meiner Kultur, aber erst jetzt verfügte ich über das Handwerkszeug zum Schreiben eines Stücks. Wir gingen immer mit unseren Eltern ins Theater, als wir klein waren. Die kleinen Theater in den Gemeindezentren und Rathäusern waren ein wichtiger Bestandteil der Walisisch sprechenden Gemeinden. Erst in den siebziger Jahren wurden die größeren Staatstheater gebaut. Die von den Engländern vertretene Meinung, alles, was man in Wales täte, wäre zu singen, ist ein Klischee. Das letzte Theaterstück in walisischer Sprache, das ich gesehen habe, war *Gymerwch chi Sigarèt?* (Hast du eine Zigarette?) von Saunders Lewis am Theatre Harlech. Saunders Lewis war ein Zeitgenosse von Kate Roberts. Die beiden sind für die Waliser, was Sartre und de Beauvoir für die Franzosen sind.

ION ON nahm seinen Anfang im Rahmen eines ortsspezifischen Projektes, das ursprünglich für den Yorkshire Sculpture Park geplant war. Ich konzipierte die Arbeit als Theaterstück, das im Freien unter einer prächtigen großen Libanonzeder neben einem Herrenhaus aufgeführt werden sollte. Alle Baum-Verweise in *ION ON* haben mit dieser Tatsache zu tun (der Baum des Lebens / der Stand des Wissens), ebenso die Verweise auf „das große Haus auf dem Hügel" in der zweiten Szene, die später durch Einbindung des verlassenen Bergwerks in das Drehbuch aufgenommen wurde. All unsere Gedanken entstammen irgendeinem Teil der Umwelt.

Inzwischen hatte ich den Begriff des Ortsspezifischen dank eigener Erfahrungen grundlegend erweitert, was sich nicht nur auf das Einbeziehen des physischen, sondern auch des gesellschaftlichen Kontextes auswirkte, denn ich hatte erkannt, dass beide tief greifende Auswirkungen aufeinander hatten. Ich hatte erlebt, dass meine eigenen Arbeiten – und die anderer Künstler – durch den Eingriff von Kuratoren transformiert worden waren, und diese Veränderungen wirkten sich im Wesentlichen nachteilig auf sie aus.

Die Aussage des Erzählers in der ersten Szene von *ION ON,* dass jetzt TIONs und ITIONs Traum folge, bedeutet dasselbe wie die Aussage: „Dies ist ein Kunstwerk." Bei beiden handelt es sich um linguistische Konstruktionen, denen ein tiefer Sinn für Ironie zugrunde liegt. Und aus dem Inhalt von TIONs und ITIONs Traum lässt sich folgern, dass es sich bei beiden um Künstler handelt.

Einerseits basieren einige meiner Aquarelle auf eigenen Träumen, andererseits gibt es da noch Freuds *Traumdeutung*. Früher pflegte man die Zukunft vorherzusagen, indem man Träume deutete, ganz zu schweigen von „I have a dream . . .", eine der unvergesslichsten Anfänge für eine Rede. Traum, Zukunft, Vision, Paradigma.

In vielen Bildern des Films lässt sich eine traumartige Qualität ausmachen, die sich zum Teil dem verwendeten Filmmaterial verdankt, einem Fuji-Negativfilm, welcher die Farben im Unterschied zum Kodak-Negativ abdämpft. Auch der Drehort Sardinien wirkt zuweilen traumartig. Ebenso auch die künstliche Situation mit dem Mann im schwarzen, sehr förmlichen Anzug. Obwohl das Ganze in einer äußerst staubigen Umgebung statt findet, scheinen seine Schuhe und sein Anzug kein bisschen schmutzig zu werden. Zudem ist er offensichtlich mutterseelenallein.

Die letzte Szene (45), diejenige mit dem Pferd, muss im Kontext einer früheren Szene (15) gedeutet werden, auf die sie zurückverweist. Wenn man nicht mitbekommt, was zuvor über ein bestimmtes Pferd mit Namen *Übersetzung* (Translation) gesagt wurde, dann versteht man auch nichts von dem, was zum Schluss über dasselbe Pferd gesagt wird. Die erste Pferdereferenz findet ganz am Ende von Szene 3 statt. Das Pferd verweist an dieser Stelle auf Freuds Darstellung der Stärke des menschlichen Willens. Man muss ihn bei den Zügeln oder bei der Mähne festhalten. Weiterhin gibt es hier einen kunsthistorischen Bezug auf die Pferde bei Kounellis. Die letzte Szene wiederum ist ein Resümee oder eine Rekapitulation beziehungsweise ein Schnelldurchlauf durch sämtliche Hauptteile oder Grundsatzfragen von *ION ON*. Ursprünglich sollte es für alle diese 13 Aussagen jeweils eine Szene geben.

Fenster / Rahmen

„Unsere Kenntnis der Sprache und der Art und Weise ihrer Anpassung zur Beherrschung bestimmter Sprechsituationen bildet einen wesentlichen Teil unseres kulturellen Wissens:
'Der Diskurs (und Sprache im Allgemeinen) ist Teil der Kultur: Weil Kultur ein Bezugssystem des Agierens, Glaubens und Verstehens ist, stellt die Kultur den Rahmen dar, innerhalb dessen Kommunikation (und die Verwendung von Aussagen) Bedeutung erhält (Schiffrin, 1994:408).' Das heißt nicht, dass alle, die einer bestimmten Kultur entstammen, genau dasselbe kulturelle Wissen besitzen. Es gibt zwar große Überschneidungen, allerdings ist das individuelle kulturelle Wissen in gewisser Weise persönlich deckt sich nicht vollständig mit dem Leitfaden oder Handbuch für alle Gruppenmitglieder [Wie das Handbuch zum *Großen Glas* von M. D.]. Ein solches Wissen hängt wenigstens teilweise von der persönlichen Erfahrung im Hinblick auf bestimmte Aspekte unserer Umgebung, unserer Erziehung und unserer individuellen Veranlagung ab (beispielsweise von unserer Fähigkeit zum Sprachgebrauch, unserer Lern- oder Anpassungsfähigkeit gegenüber neuen Sachverhalten)."
(*Exploring the French Language*, S. 176 f.)

(Odyssee)

Wenn ein derartiges Sprechen / Schreiben eine Odyssee ist, wo / was ist dann Ithaka? Die Heimat beziehungsweise Ithaka liegt im Kunstwerk.

Übersetzung Ralf Schauff

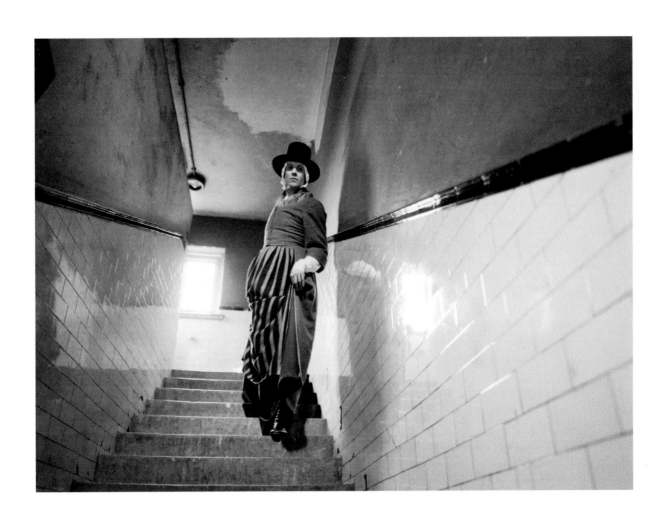

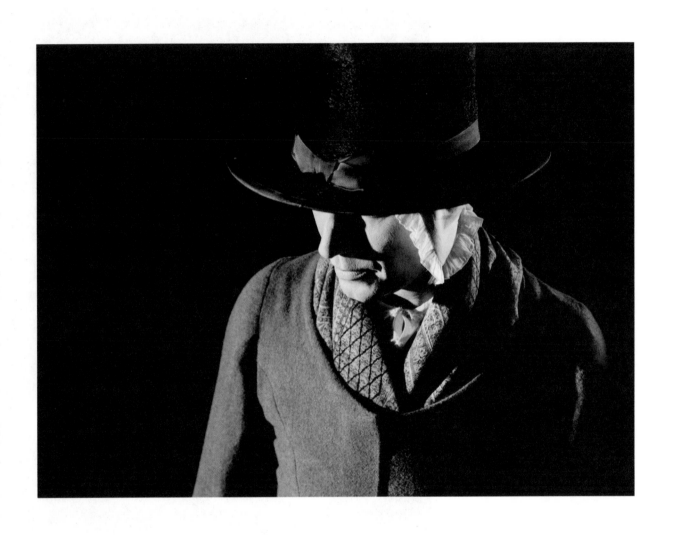

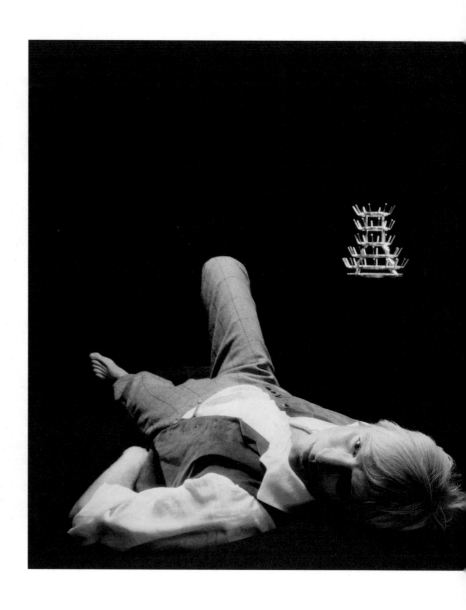

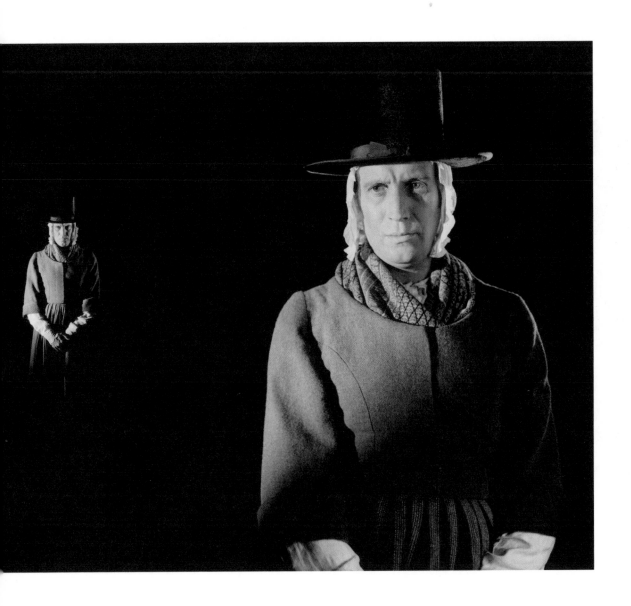

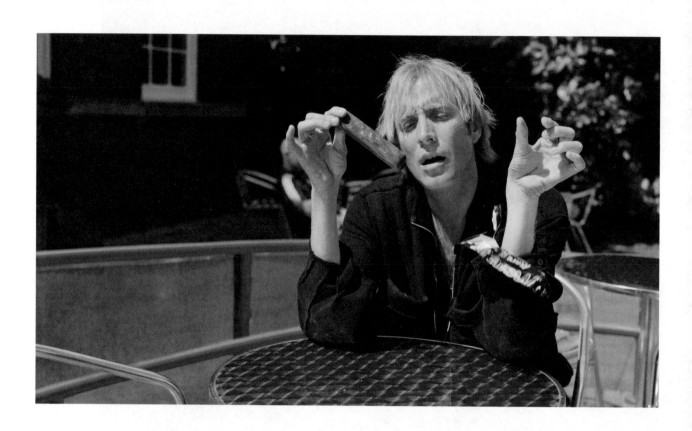

Bethan Huws: language, movement and film

I

In the opening shot, the camera captures an accumulation of points of light that merge into one another. Only gradually does this blurred mass solidify – as if I have rubbed my eyes in order to be able to see anything at all – into a fixed image; it detaches itself from the black background and presents a close-up view of an assembled structure with a smooth surface that reflects the light, while the surrounding shadows give it three-dimensional form. This is followed by a black screen that leads into a non-specific filmic space, before the title of the piece – *The Chocolate Bar* – appears in white letters and is simultaneously announced by a male voice. At this point everything is still shrouded in darkness. However, in the very next shot of this, Bethan Huws' fourth film[1], which was made in 2006 and is just under four and a half minutes long, the previously introduced structure is brought to the fore and disclosed as the bottle rack – one of Duchamp's first readymades. This readymade enables Huws to reveal transitions: between blurring and sharpness of focus as specifically filmic devices; between things that are indecipherable or recognizable depending on the chosen image detail; between the history and the updating of the readymade. The bottle rack is transformed, as it were, into an eye before which the film unwinds, and by making reference to an exterior realm and to art history, it brings into play something that precedes the film. In *The Chocolate Bar*, the readymade provides the framework which opens up the piece and makes 'film as film' one of its themes. The deferred meaning of the readymade – which, having been chosen to perform this role, is per se a secondary object – becomes the starting point of the film.

A young, blonde-haired man, wearing a loose-fitting white shirt and waistcoat, is first seen – again initially as a blurred shape – lying on his back and gazing out beyond the frame of the image. What is his gaze fixed upon? Does he see, as the viewer does, the bottle rack as a skeleton hovering in the black expanse? As soon as the camera has focused on the young man, the regular pattern of his breathing begins to give rhythm to the image, recalling the sleeping poet John Giorno in Andy Warhol's film *Sleep* (1963):

the rise and fall of his chest seems to coincide with the opening and closing of the observing eye – the blink of its eyelids. Huws brings the camera in from behind, moving it closer to the protagonist's head as if she were able to listen in to the trains and convolutions of his thoughts. Then it cuts to a steep staircase, filmed from a frontal and slightly lower angle. A female figure sweeps down the stairs. She is not, however, naked – as one might have assumed from the allusion to Duchamp's painting *Nu Descendant un Escalier*. Huws' female character wears a long dress with a tight bodice – a Welsh national costume. Welsh culture with its long theatrical tradition, including that of male actors performing in female dress (like Duchamp as *Rrose Sélavy*), is the biographical and collective store that provides the framework for Huws' film; the first question asked by the character dressed as a Welsh Lady – "Where does he come from, Mars?" – at the point where all three protagonists are on screen, then seems to refer to the bottle rack, and locates the source of the readymade somewhere off-screen: coming from Mars, extraterrestrial, alien. This question suggests the possibility of a narrative about origins and history[2]: where does the readymade come from, given that it is the result not of a genealogical process but of an act of choosing, of dating and naming – of language itself? In Bethan Huws' work everything is permanently at stake: what is art, when art like language is concerned with transfer movements, with portraying a particular form of exchange between understanding, interpreting and acting, with the constant rewriting of our surroundings as they are directly perceived? This is why, in the ensuing dialogue between the young man and the woman (both played by the Welsh actor Rhys Ifans, who has made a name for himself in the American film industry), every potentially coherent narrative thread leads nowhere. Instead, words and sentences are pushed back and forth, their meaning breaking down, being overturned and recharged with each new articulation. The word 'Mars' contains a veritable galaxy of meanings: for example, it is a month in spring in the French language, a god of war in ancient myth, a planet named after its red light reminiscent of blood and fire, and, last but not least, a famous chocolate bar. In her film, Bethan Huws places words and sentences in a minimal linguistic setting that is permeable enough to prevent any specific semantics from being conveyed. The text on which Huws' film script is based was previously

installed by the artist in 2003, set out in large orange letters on the high wall of the so-called Kinosaal (cinema hall) in the Düsseldorf Kunsthalle. On that occasion, Huws responded to a concrete spatial situation with the ambiguity of her text *The Chocolate Bar*, making it possible for the space to be experienced and read in a new way.[3] Language, initially set in a spatial dispositive, precedes the filmic rendering. The relationships between words that Huws forms in her text cannot be reconstructed, but rather display their specifically topological qualities, in particular the capacity to become confused and slurred. The very title of the text – *The Chocolate Bar* – is itself ambiguous, a play on words; as a locale and an object, this particular combination of words seems to represent both the film's setting and film itself, i.e. art, in a programmatic sense. Huws' work deals in a variety of ways with language and its function of producing both understanding and misunderstanding. She is interested in the delays in meaning which occur in everyday communication and the discrepancies caused as a result, in the deferment and constant promise of meaning that is never fulfilled. Significantly, in *The Chocolate Bar* it is the female character that has been created as a persona without substance; her obvious artificiality – the fact that she is male and female at once, the manner of her dress – prevents her from becoming an object of desire, and her seemingly incoherent and meaningless speech is irritating. By means of her hybrid nature, which is genuinely filmic, the dysfunctionality of language, meaning and understanding is given visual expression.

II

Whereas the first part of the film is shot in black-and-white, in the second part colour is used to continue the dialectic conditions and at the same time indicate a shift in the filmic reality. Huws instructed Ifans to eat a Mars bar as if this lump of chocolate were "the most delicious thing in the world". He appears now not as an actor, but as himself; wearing his own clothes, he sits alone (apart from a few people conversing in the background) at an outdoor bistro table, where he begins to devour the Mars bar in a much more theatrical manner than when he previously played his assigned part. He breaks the caramelized chocolate mass into two pieces, rolls these into balls in the

palms of his hands and proceeds to stuff them into his mouth, grunting contentedly. Like Duchamp's bachelor who grinds his chocolate himself, Ifans needs no further assistance in the performance of his autoerotic act. This part of the film contains no written or spoken text, but the scene has a concrete spatial location, in contrast to the disorienting black background of the first part. Huws captures the scene (which explores what can occur *after* the structure determined by the artist, and in which both the actor and the Mars bar become readymades) in a single take filmed from a frontal and slightly lower angle. However the film does not continue this real-time paradigm; instead it breaks off. The picture is suddenly gone, leaving only the background noises as its afterimage for a few additional seconds. The balls of chocolate are left bulging out Ifan's cheeks – as if the film were saying, with a typically Duchampian, ambivalent mixture of seriousness and irony: *With My Tongue In My Cheek*.

Language, together with the polyphonic, three-faced persona from the first part of Huws' film, is replaced in the second part by the *movens*, the motivation and movement of the spoken text, which is namely to strip the words of their meaning, to scrape out their insides until they are nothing but hollow shells. With the chocolate bar, everyday linguistic usage removes the possibility of a single, univocal meaning of the term, and it thus becomes resynthesized into an object, a readymade. The film does not go beyond the consumption of the chocolate – it is not digested, as if such excessive enjoyment could be prolonged using filmic means. Huws' film therefore does not reach its climax at the point where it goes over from the first to the second part – from black-and-white to colour and from the level of language to that of sounds – nor where it ends; the climax actually occurs off-screen – which is also the place from which the readymade – the bottle rack – comes. There is a similarity here to Warhol's *Eat* (1964), where Robert Indiana doesn't actually eat the mushroom but seems to chew on it endlessly; what here might evoke a kind of intoxication is ultimately not the specific composition of the plant, but rather the depiction of this situation *as a film* that is constantly recharged by the way the separate strips of film are joined together. These specifically filmic means, therefore, which have the effect of defamiliarizing everyday communicative acts (such as eating), do not aim to provide visual satisfaction or to pursue a particular

performative action to completion, but instead – when perpetuated – to produce a state of suspension between being incomplete and being undecided, one that remains charged with tension as a result.

When, in the second part of *The Chocolate Bar*, Huws uses colour rather than black-and-white film, sounds (lip-smacking, chair scraping and voices in the background) rather than spoken text, and Rhys Ifans himself rather than a role played by him, the question is raised as to why this very division of the film into two parts can make language itself the subject of the film. The specific quality of the image that is filtered out by Huws through the medium of film is that it neither narrates nor represents but instead explores the interfaces between space, time and movement, which are linguistically structured. The filmic structure of *The Chocolate Bar* is dialectically organized and operates with antonyms in which different levels of perception interact: the image and the viewer, imagination and interpretation, an extralinguistic element and – through the readymade – a language of *Nachträglichkeit*. The notion of *Nachträglichkeit* ('deferred action' or the retrospective attribution of meaning) is also a key concept in Sigmund Freud's psychoanalytical theory, where it describes a reworking of events or situations that have previously not been able to be integrated into a context of meaning. An impulse that is incomprehensible at the time of its occurrence and is therefore repressed, returns – belatedly –, and it is precisely in the course of such recurrences and restructurings that changes in perception become evident.[4]

Language is a mould, whereas cinema is modulation, as Gilles Deleuze wrote. For not just voices, but also sounds, lights and movements are constantly being modulated. As "parameters of the image" they are subject to variations, repetitions, alternations, recycling etc. This leads to a "transition from visibility to legibility" of images.[5]

III

"The house is language – behave as if it's your palace" (pg. 144) – this text can be read next to a framed drawing by Bethan Huws that is based on a video image she created in preparation for *ION ON* (2003)[6], an hour-long film she made prior to *The Chocolate Bar*, and it would seem that this play on words placed alongside the drawing contains some

basic instructions for filmmaking itself: working with images invariably involves linguistic moulds and initiates transfer processes. While the video images made prior to the shooting of the film form part of the exploration of the concrete site and act like sketches used to store memories of images, the subsequently produced drawings are not to be compared with a storyboard, but in fact serve to give the film a particular rhythm and to structure the sequence of individual images. The drawings for Bethan Huws' most recent film *Fountain*, on the other hand, are based directly on her 16mm film footage, and enable the artist not only to get an overall picture of the 49 fountains she filmed in Rome but also to put the frames in order, create sequences and develop the filmic progression. Being derived from the video material, the drawings for *ION ON* operate on a different basis – in terms of colour, frame and sharpness of focus – to those for *Fountain*; whereas the former are functional and are employed as a projective tool to elucidate what could potentially happen during the filming process, the *Fountain* drawings play a constitutive role in the way the film is edited. "I practise my editing by drawing," Huws says, implying that her approach to film is influenced by the various possibilities of working with filmic material and its specific relationship to other media such as text, language or indeed drawing.

While the specific movement of the images in *Fountain* is ultimately provided by a text composed by Huws and also spoken by her, underlain with the sound of splashing water recorded at night, in *ION ON* the dialogical structure is condensed into a monologue by the sole protagonist - as can also be inferred from what a narrative voice tells us in the prologue: "A new situation / arises between two people. () She named TION. He named ITION. ()" The figure being described therefore has neither an origin nor a history; its presence is generated by the specifically filmic movement and time. A young man, dressed in black, stands, strolls, runs and jumps through a long-abandoned, ruinous-looking industrial site, in surroundings that consist of layered fields, hills and dunes, somewhere in Sardinia. Not only are all the stops of dramatic art pulled out – "Again. Practise. Repeat. Up and down those piano scales." (Scene 42) –, male and female figures also intertwine, typologies such as that of the artist or the curator are superimposed, and communication processes, questions, comments, interpretations

and misunderstandings are concentrated into one person, one monologue, because: "What we all practise is speech." (Scene 42). Filmed from many different angles, using both short and long tracking shots, close-ups and wide shots, the camera never stops weaving its way through the scenic wasteland and the delirious text, whereby we are not always sure right away who is speaking or who is actually being addressed. The mainly lateral movement of the camera explores the topological dimension of the image by capturing a wide variety of (conversational) situations, linking them together and then separating them again – scanning and illuminating the language. The title of the 35mm film, *ION ON*, traces back to the suffix -tion, a fundamental element of several languages that forms a wide range of nouns such as 'situation', 'reflection' or 'action'. The two names – ITION and TION – derive from this suffix and are subsequently – similar to a classical analytical process – filtered further and reduced: "Joyce discovered through his practice. How to arrange letters. He found in / words. He moved them around. He then made them fit his purpose." (Scene 23).

IV

In Bethan Huws' work, words and situations go hand in hand with an analogy of language and history. This relationship between performance and recording, speech and language, linguistically generated and filmically evoked space is impressively conveyed, particularly in the 6th scene of *ION ON* – the so-called 'Brecht scene': the camera opens onto a broad natural landscape, a field of artichokes where the linear arrangement of plants draws a perspectival line into the depth of the picture before deflecting the viewer's gaze towards the line of the horizon. In anticipation of this movement, the protagonist, approaching from the right-hand side, moves in large steps across the centre of the picture, as if he were going back along – retracing, recalling – a stretch he has already travelled, a scene that has already been realized: "Helps clear. The air. *(Heir)*." This conception not only creates an image of distance through the text with its underlying Brechtian theory of alienation, it also produces an inherently filmic form of reflection: two scenes previously the actor is seen wading over the dunes, *entering* the pictorial space. The signs of time passing, which have been left by his

footsteps in the sand, are given spatial form by the film and laid down here like writing.

In *ION ON*, walking indicates a twofold movement: on the one hand by fanning out into a variety of speech moments and speakers, and on the other by spatializing the dialogical situation between language and image, figure and camera. The static camera in Huws' film *Fountain*, however, is the expression of a photographic dispositive that makes the images seem abandoned and open at the same time. Whereas in *The Chocolate Bar* movement is portrayed by the division into two parts that provides the structure for the entire film, in *Fountain*, movement is not generated primarily by the cuts between individual images but rather by the virtually never-ending stream of water which synchronizes with Huws' off-screen voice reading her own text on Duchamp's *Fountain*. "Fills the screen. The Bowl. / Stream running between Teeth. One continuous line, unbroken. Constant energy Flow"(pg 156). Film, movement and language literally flow into fountains, into sources of play.

Maja Naef

Translated from the German by Jacqueline Todd

1 Bethan Huws has made five films to date: *Singing for the Sea*, 1993 (16mm, colour, sound, 12'), *ION ON*, 2003 (35mm, colour, sound, 60 mins), *Architecture*, 2004 (16mm, transferred to DVD, colour, no sound, 7'), *The Chocolate Bar*, 2006 (35mm, b/w and colour, sound, 4'25''), *Fountain* (16mm, colour, sound, work in progress).
2 On this theme see also Huws' six-volume textual work *Origin and Source*, 1993–1995.
3 Cf. Ulrike Groos, 'Bethan Huws: Spaces', in *Bethan Huws. Selected Textual Works 1991–2003*, published by Dieter Association Paris and Kunsthalle Düsseldorf, exhib. cat. Kunsthalle Düsseldorf, 2003, pp. 182–184; here p. 182f.
4 Freud defined the concept of *Nachträglichkeit* in a number of texts, including the case of the Wolf-Man in 'From The History of An Infantile Neurosis' (1918), in *The Standard Edition of the Complete Psychological Works of Sigmund Freud*, vol. XVII, ed. and trans. James Strachey, London, 1975; on this topic see also Jean Laplanche and Jean-Bertrand Pontalis, *The Language of Psychoanalysis*, trans. Donald Nicholson-Smith, New York, 1973, pp. 111–14, and Jacques Derrida, 'Freud and the Scene of Writing', in *Writing and Difference*, trans. Alan Bass, Chicago, 1978, pp. 196–231.
5 Gilles Deleuze, 'On The Movement-Image' (1983), in *Negotiations* 1972–1990, trans. Martin Joughin, New York, 1995, pp. 46–56: here p. 53.
6 See Julian Heynen's detailed analysis, '*ION ON* – A Film', in *Bethan Huws. Selected Textual Works 1991–2003*, op. cit., pp. 164–166. The script of the 45 scenes that make up the film *ION ON* (2001–2003) – 'A critical comedy' – is also published in this catalogue.

Bethan Huws: Sprache, Bewegung und Film

I

Was die Kamera mit der ersten Einstellung einfängt, ist eine Ansammlung von ineinander fliessenden Lichtpunkten. Erst allmählich verdickt das Verschwommene – als würde ich mir die Augen reiben, um überhaupt zu sehen – zu etwas Festem, löst sich vom schwarzen Hintergrund ab und zeigt in Nahansicht eine verschraubte Struktur mit einer glatten Oberfläche, an der das Licht sich spiegelt, während sie von Schatten plastisch modelliert wird. Darauf folgt ein schwarzes Bild, das in einen unspezifischen filmischen Raum einführt, bevor in weissen Lettern der Titel *The Chocolate Bar* erscheint, welcher gleichzeitig von einer Männerstimme rezitiert wird. Noch liegt alles im Dunkeln verrätselt. Doch schon die nächste Einstellung des 2006 entstandenen und knapp viereinhalb Minuten dauernden vierten Films von Bethan Huws[1] lässt die eingangs eingeführte Struktur als den Flaschentrockner, eines der ersten Readymades von Duchamp, hervortreten. Das Readymade dient Huws zur Freilegung von Übergängen: denen zwischen verschwommen und fokussiert als spezifisch filmischen Mitteln, zwischen unentziffert und wiedererkannt aufgrund des gewählten Bildausschnittes, zwischen Geschichte und Aktualisierung des Ready-mades. Der Flaschentrockner verwandelt sich gleichsam in ein Auge, vor dem der Film sich abrollt. Und er bringt etwas ins Spiel, was dem Film vorausgeht, indem er auf ein Aussen und eine Geschichte der Kunst Bezug nimmt. Das Readymade figuriert in Huws' Film als Rahmen, der den Film eröffnet und den Film als Film zum Gegenstand macht. Die Nachträglichkeit des Readymades – das per se ein sekundäres, weil gewähltes Objekt ist – wird zum Ausgangspunkt des Films.

Ein junger Mann mit blondem Haar, in weissem weitem Hemd und Gilet liegt zunächst als wiederum unscharf aufgenommene Gestalt auf dem Rücken und schaut aus dem Bildfeld hinaus. Woran orientiert sich sein Blick? Sieht er den Flaschentrockner wie der Betrachter als ein im schwarzen Raum schwebendes Gerippe? Sobald die Kamera den Jüngling scharf stellt, beginnt sein regelmässiges Atmen das Bild zu rhythmisieren, was an den schlafenden Dichter John Giorno in Andy Warhols Film

Sleep (1963) erinnert; das Aufblähen und Absenken des Brustkorbs scheint mit dem Öffnen und Schliessen des betrachtenden Auges – seinem Lidschlag – zusammen zu fallen. Huws lässt die Kamera von hinten nah an den Kopf ihres Protagonisten heran-rücken, als könnte sie in die Ströme und Faltungen des Denkens hineinhorchen. Ein Schnitt zu einer steilen Treppe, die Huws frontal und in leichter Untersicht aufnimmt. Eine weibliche Figur gleitet über die Stufen. Doch ist sie nicht, wie man aufgrund der Anspielung auf Duchamps Gemälde *Nu Descendant un Escalier* vermutet hätte, nackt. Huws' weibliche Figur trägt ein langes, streng geschnürtes Kleid, ein traditionelles walisisches Kostüm. Die walisische Kultur mit ihrer langen Theatertradition, welche auch jene beinhaltet, in der männliche Schauspieler als Frauen verkleidet auftraten (wie Duchamp als *Rrose Sélavy*), bildet den sowohl biografischen wie auch kollektiven Fundus, den Huws zur Kadrage des Films macht: Die erste Frage der verkleideten Welsh Lady „Where does he come from, Mars?", als alle drei Protagonisten im Bild sind, scheint sich denn auch auf den Flaschentrockner zu beziehen und situiert die Herkunft des Readymades im Off: vom Mars kommend, ausserirdisch, fremd. Mit dieser Frage scheint sich das Potenzial einer Erzählung über Ursprung und Geschichte[2] anzudeuten: Woher kommt das Readymade, wo es doch nicht aus einem genealogischen Prozess, sondern einem Akt der Wahl, des Datierens und Benennens – der Sprache selbst – hervorgeht? Bei Bethan Huws steht immer alles auf dem Spiel: Was ist Kunst, wenn es in der Kunst wie in der Sprache um Übertragungsbewegungen geht, um die Dar-stellung einer bestimmten Form des Tausches zwischen Verstehen, Interpretieren und Handeln, ein ständiges Umbuchstabieren der unmittelbar wahrgenommenen Umgebung. Darum muss im Dialog, welcher sich zwischen Jüngling und Frau, beide vom walisischen Schauspieler Rhys Ifans dargestellt, der sich in der amerikanischen Filmindustrie einen Namen gemacht hat, zu entspinnen beginnt, jeder kohärent narrative Strang ins Leere laufen. Stattdessen werden Wörter und Sätze hin und her geschoben, ihre Bedeutung bricht mit jeder erneuten Artikulation zusammen, stülpt sich um und lädt sich neu auf. Das Wort „Mars" bündelt in sich geradezu ein buch-stäbliches Universum von Bedeutungen: in der französischen Sprache ist es ein Frühlingsmonat, ein Kriegsgott in der antiken Mythologie, ein Planet aufgrund seines

roten, an Blut und Brand erinnernden Lichts und schliesslich der bekannte Schoko-
ladenriegel. Bethan Huws hüllt in ihrem Film Worte und Sätze in eine minimale
Sprachumgebung, die durchlässig genug ist, keine Semantik zu verfestigen. Den Text,
den Huws dem Film als Script zugrunde gelegt hat, installierte sie bereits 2003 in
grossen orangen Buchstaben an der hohen Wand des so genannten Kinosaals in der
Düsseldorfer Kunsthalle. Huws reagierte dort mit der Vieldeutigkeit ihres Textes *The
Chocolate Bar* auf eine konkrete Raumsituation, welche dadurch auf neue Weise erfahr-
und lesbar wurde.[3] Sprache, zunächst in ein räumliches Dispositiv gespannt, geht
der filmischen Übertragung voraus. Die Beziehungen, die Huws in ihrem Text zwischen
Wörtern knüpft, sind nicht rekonstruierbar, sondern weisen ihre spezifisch topolo-
gischen Qualitäten auf, die Möglichkeit nämlich, sich mit- und untereinander zu
verschleifen. Schon der Titel, *The Chocolate Bar*, ist uneindeutig und ein Wortspiel:
Als Raum und Gegenstand scheint die Wortkombination programmatisch für einen Ort
des Films und den Film selbst, d.h. die Kunst, zu stehen. Huws setzt sich in ihrer Arbeit
auf unterschiedlichste Weise mit Sprache und ihrer Funktion, Verstehen und Missver-
stehen zu produzieren, auseinander. Sie interessiert sich für Bedeutungsverzögerungen
in der täglichen Kommunikation, die daraus hervorgehenden Differenzen, den Auf-
schub und das ständige Versprechen von Sinn, welches sich nie erfüllt. Bezeichnen-
derweise ist es in *The Chocolate Bar* die weibliche Figur, welche als eine Persona ohne
Substanz entworfen ist: ihre offensichtliche Künstlichkeit – zugleich männlich und
weiblich sowie (ver)kleidet – verhindert, dass sie zu einem Objekt des Begehrens wird.
Ihre scheinbar zusammenhangs- und sinnlose Rede irritiert. In ihrem Mischwesen, das
genuin filmisch ist, wird die Dysfunktionalität von Sprache, Bedeutung und Verstehen
ins Bild gesetzt.

II

Ist der erste Teil des Films in schwarz-weiss gehalten, führt die Farbe im zweiten Teil die
dialogische Struktur fort und zeigt auch einen Wechsel in der filmischen Wirklichkeit
an. Huws hat Rhys Ifans aufgetragen, einen Mars-Riegel so zu verzehren, als sei dieses
Schokoladenstück das Beste überhaupt auf der Welt: „the most delicious thing in the

world". Nicht als Schauspieler, sondern in seinem eigenen Shirt sitzt er alleine umgeben von ein paar wenigen sich unterhaltenden Personen im Hintergrund an einem Bistrotisch im Freien und beginnt, sich das Mars einzuverleiben, theatralischer als in seinem zuvor gespielten Part. Er zerteilt die karamelisierte Schokoladenmasse, knetet sie zu kleinen Bällen, um sie schliesslich genussvoll grunzend in seinen Mund hineinzustopfen. Wie der Junggeselle bei Duchamp, der seine Schokolade selbst reibt, braucht Ifans keine weitere Hilfe für seinen auto-erotischen Akt. Es gibt denn auch weder geschriebenen noch gesprochenen Text, dafür aber eine konkrete räumliche Situierung der Szene, die mit dem desorientierenden schwarzen Hintergrund des ersten Teils korrespondiert. Huws nimmt diesen Akt, der untersucht, was sich *nach* einer durch die Künstlerin vorgegebenen Struktur ereignen kann (und in dem Schauspieler und Mars gleichermassen zu Readymades werden), in leichter Untersicht frontal und in einer einzigen Kameraeinstellung ohne Schnitt auf. Der Film hält dieses Realzeit-Paradigma jedoch nicht durch, er bricht ab; unvermittelt verlöscht das Bild, und lässt für wenige Sekunden noch die Nebengeräusche als Nachleben des Bildes übrig. Die Schokoladenbälle jedenfalls beulen Ifans' Wangen noch aus, als würde der Film mit Duchamps bezeichnender Ambivalenz aus Ernsthaftigkeit und Ironie sagen *With My Tongue In My Cheek*.

An die Stelle der Sprache, der mehrstimmigen und dreigesichtigen Persona im ersten Teil von Huws' Film, hat sich im zweiten Part der eigentliche Movens des gesprochenen Textes geschoben, nämlich den Wörtern ihre Bedeutung herauszureissen und sie auszuschaben bis sie nurmehr Hohlformen darstellen. Im Schokoladenriegel re-synthetisiert sich die permanente Entwendung einer einstimmigen Bedeutung im alltäglichen Sprachgebrauch zu einem Objekt, einem Readymade. Es bleibt beim Verzehr der Schokolade, denn verdaut wird sie nicht; als könnte derart ein exzessives Geniessen mit filmischen Mitteln in die Länge gezogen werden. So ereignet sich auch die Klimax im Film von Huws weder da, wo der Film vom ersten in den zweiten Teil übergeht, von schwarz-weiss in Farbe, von der Sprach- in die Geräuschebene, noch dort, wo er endet, sondern im Off, von wo auch das Readymade – der Flaschentrockner – herkommt. Wie Robert Indiana in Warhols *Eat* (1964) den Pilz nicht isst, sondern endlos zu kauen

scheint, ist es letztlich nicht die spezifische Zusammensetzung der Pflanze, die eine Art von Rausch evozieren könnte, als vielmehr die Darstellung der Situation *als* Film, der sich durch die Aneinanderfügung einzelner Filmstreifen immer wieder neu auflädt. Die spezifisch filmischen Mittel also, welche alltägliche kommunikative Handlungen (wie Essen) verfremden, zielen nicht auf Sättigung bzw. den restlosen Vollzug einer bestimmten Handlung, sondern bringen einen Zustand hervor, der – perpetuiert – zwischen Unabgeschlossen- und Unentschiedenheit angehalten wird und dadurch spannungsgeladen bleibt.

Setzt Huws im zweiten Teil von *The Chocolate Bar* farbiges anstelle von schwarz-weissem Filmmaterial, Geräusche (Schmatzen, Stuhlrücken oder Stimmen im Hintergrund) anstelle von vorgetragenem Text sowie Rhys Ifans' selbst statt eine von ihm gespielte Rolle ins Bild, drängen sich Überlegungen dazu auf, wie gerade durch diese Zweiteilung im Film Sprache selbst zum Gegenstand des Films werden kann. Das Spezifische am Bild, welches Huws mit dem Medium des Films herausfiltert, ist, dass es weder erzählt noch repräsentiert, sondern vielmehr die Nahtstellen untersucht zwischen Raum, Zeit und Bewegung, welche sprachlich strukturiert sind. Die filmische Struktur von Huws' *The Chocolate Bar* ist dialektisch organisiert und verfährt mit Antonymien, durch die verschiedene Wahrnehmungsebenen ineinander greifen: Bild und Betrachter, Imagination und Interpretation, etwas Aussersprachliches und – durch das Readymade – eine Sprache der Nachträglichkeit. Nachträglichkeit ist denn auch in Sigmund Freuds psychoanalytischer Konzeption zentral und bezeichnet ein Umarbeiten von Ereignissen oder Situationen, die bis dahin in keinen Bedeutungszusammenhang integriert werden konnten: Was unverständlich geblieben ist und darum verdrängt wurde, das kommt wieder – verspätet –, und gerade im Zuge solcher Wiederholungen und Umformulierungen zeigen sich Veränderungen in der Wahrnehmung an.[4]

Die Sprache sei eine Gussform, während der Film moduliere, schreibt Gilles Deleuze. Denn nicht allein die Stimmen, sondern auch die Töne, Lichter, Bewegungen seien in ständiger Modulation begriffen. Als „Parameter des Bildes" werden sie Teil von Variationen, Wiederholungen, Anspielungen, Schleifen etc. Daher gerate „die Sichtbarkeit des Bildes zur Lesbarkeit."[5]

„The house is language – behave as if it's your palace" (S. 144) – steht neben einer gerahmten Zeichnung von Huws zu lesen, deren Vorlage ein Videobild ist, welches sie zur Vorbereitung ihres vor *The Chocolate Bar* realisierten einstündigen Films *ION ON* (2003)[6] angefertigt hat, und es scheint, als würde dieses bei der Zeichnung platzierte Wortspiel für das Filmen eine grundlegende Anleitung bereit halten: Der Umgang mit Bildern geht stets mit sprachlichen Gussformen einher und leitet Übertragungsprozesse ein. Während die dem Filmshooting vorangegangenen Videoaufnahmen zur Erkundung des konkreten Orts beitragen und die Funktion von Skizzen haben, welche die Erinnerung an Bilder speichern, sind die nachträglich entstandenen Zeichnungen nicht mit einem Storyboard gleichzusetzen, sondern dienen vielmehr dazu, den Film mit einem bestimmten Rhythmus aufzuladen und die Abfolge einzelner Bilder zu strukturieren. Die Zeichnungen zu *Fountain,* dem neuesten Film von Bethan Huws, hingegen sind dem 16mm-Filmmaterial direkt entnommen und erlauben es der Künstlerin, einen Überblick über die 49 in Rom aufgenommenen Brunnen zu gewinnen, die Einzelbilder zu ordnen, Sequenzen herzustellen und einen filmischen Ablauf zu entwickeln. Den Zeichnungen zu *ION ON* liegt mit dem Videobild eine anderes Raster – was Farbe, Rahmen und Einstellungsschärfen betrifft – zugrunde, als denjenigen zu *Fountain*: Sind erstere funktional und ein projektiv auf das Filmen hin orientiertes Instrument, das klärt, was sich darin potenziell ereignen kann, sind die *Fountain*-Zeichnungen für das Edieren des Films selbst konstitutiv: „I practise my editing by drawing", sagt Huws und impliziert damit, dass ihre Auseinandersetzung mit dem Film von den Möglichkeiten des Umgangs mit filmischem Material und seinem spezifischen Verhältnis zu anderen Medien wie Text, Sprache oder auch Zeichnung gestaltet ist.

Basiert die spezifische Bewegung der Bilder in *Fountain* letztlich auf einem von Huws verfassten und auch von ihr rezitierten Text, der mit den in der Nacht aufgezeichneten Geräuschkulissen des plätschernden Wassers unterlegt wird, verdichtet sich in *ION ON* die dialogische Struktur – das ist auch dem Prolog durch eine Erzählstimme zu entnehmen – zum Monolog des einzigen Protagonisten: „A new situation / arises between two people. () She named TION. He named ITION. ()" Die Figur also hat weder Herkunft

noch Geschichte; ihre Präsenz wird aus der spezifisch filmischen Bewegung und Zeit heraus entworfen. Ein in Schwarz gekleideter junger Mann steht, schlendert, rennt oder springt durch das längst verlassene, ruinös wirkende industrielle Gelände in einer aus Feldern, Hügeln und Dünen geschichteten Umgebung irgendwo in Sardinien. Nicht nur alle Register der Schauspielkunst hervorziehend – „Again. Practise. Repeat. Up and down those piano scales." (Scene 42) –, schieben sich männliche und weibliche Figur ineinander, werden Typologien wie Künstler und Kurator übereinander geblendet und werden Kommunikationsprozesse, Fragen, Kommentare, Interpretationen und Missverständnisse auf eine Person, einen Monolog, zusammengezogen, denn: „What we all practise is speech." (Scene 42). Aus den unterschiedlichsten Winkeln aufgenommen, in kurzen und längeren Fahrten, als Totale oder Close-Up, hört die Kamera nicht auf, sich einen Weg durch diese landschaftliche Brache und den delirierenden Text zu bahnen, von dem man nicht immer sogleich weiss, wer spricht und wer denn eigentlich angesprochen wird. Die mehrheitlich lateral organisierte Bewegung der Kamera lotet die topologische Dimension des Bildes aus, indem sie verschiedenste (Gesprächs)Situationen festhält, miteinander verklammert und wieder voneinander ablöst, die Sprache abtastend, ausleuchtend. Der Titel des 35mm-Films, *ION ON*, geht auf die für mehrere Sprachen grundlegende Endung zurück, die eine Reihe von Substantiven wie „Situation", „Reflektion" oder „Aktion" bildet. Die beiden Namen – ITION und TION – sind diesem Suffix -tion entnommen und anschliessend – einem klassischen Analyseverfahren ähnlich – weiter gefiltert und reduziert worden: „Joyce discovered through his practice. How to rearrange letters. He found in / words. He moved them around. He then made them fit his purpose." (Scene 23).

IV

Wort und Situation gehen bei Bethan Huws mit einer Analogie von Sprache und Geschichte einher. Dieses Verhältnis von Aufführung und Aufzeichnung, von Sprechen und Sprache, von sprachlich generiertem und filmisch evoziertem Raum findet sich in der 6. Szene, der sogenannten Brecht-Szene, besonders eindrücklich umgesetzt: Die Kamera öffnet ihre Linse auf eine weite kreatürliche Landschaft, in der das linear

bepflanzte Artischockenfeld eine perspektivische Flucht in die Tiefe des Bildes schlägt, ehe diese den Blick dort wiederum in die Horizontlinie umlenkt. Diese Bewegung bereits vorwegnehmend, durchquert der Protagonist von rechts her kommend mit grossen Schritten die Mitte des Bildes, als würde er eine bereits gegangene Strecke, eine bereits realisierte Szene, nochmals zurück gehen, wieder aufnehmen, sich ihrer erinnern: „Helps clear. The air. (Heir)." Diese Konzeption entwirft nicht nur aufgrund ihrer durch den Text zugrunde gelegten Brechtschen Verfremdungstheorie ein Bild des Distanzierten, sondern auch eine filmimmanente Reflexion: Der Darsteller watet zwei Szenen zuvor noch über einen Dünenhügel *in* den Bildraum hinein. Die Zeichen der dabei zerronnenen Zeit, welche seine Schritte im Sand hinterlassen haben, werden durch den Film in den Raum übertragen und darin abgelegt wie einen Schriftzug.

Das Gehen in *ION ON* zeigt eine zweifache Bewegung an, indem es sich einerseits in verschiedenste Sprechmomente und Sprachträger auffächert, und andererseits die dialogische Situation zwischen Sprache und Bild, Figur und Kamera verräumlicht. Die statische Kamera in Huws' Film *Fountain* hingegen ist Ausdruck eines fotografischen Dispositivs, das die Aufnahmen verlassen und gleichzeitig offen wirken lässt. Hat in *The Chocolate Bar* die den ganzen Film strukturierende Zweiteiligkeit Bewegung ins Bild gesetzt, ist es in *Fountain* gerade nicht primär der Schnitt zwischen den einzelnen Bildern, der Bewegung generiert, sondern der nie wirklich abreissende Wasserstrahl, welcher sich mit Huws' Stimme im Off, die ihren zu Duchamps *Fountain* verfassten Text selbst liest, synchronisiert. „Fills the screen. The Bowl. / Stream running between Teeth. One continuous line, unbroken. Constant energy Flow"(pg 156): Film, Bewegung und Sprache gerinnen buchstäblich zu Fountains, zu Quellen des Spiels.

Maja Naef

1 Bislang hat Bethan Huws fünf Filme realisiert: *Singing for the Sea*, 1993 (16mm, Farbe, Ton, 12'), *ION ON*, 2003 (35mm, Farbe, Ton, 60'), *Architecture*, 2004 (16mm, auf DVD übertragen, Farbe, ohne Ton, 7'), *The Chocolate Bar*, 2006 (35mm, s/w und Farbe, Ton, 4'25''), *Fountain* (16mm, Farbe, Ton, work in progress).
2 Vgl. zu dieser Thematik auch Huws sechs Bände umfassende Textarbeit *Origin and Source* von 1993–1995.
3 Vgl. dazu Ulrike Groos, „Bethan Huws: Räume", in: *Bethan Huws, Selected Textual Works 1991–2003*, hg. v. Dieter Association Paris und Kunsthalle Düsseldorf, Ausst.-Kat., Kunsthalle Düsseldorf, 2003, 186–188: 186f.
4 Der Begriff der „Nachträglichkeit" hat Freud in verschiedenen Texten ermittelt, z.B. in „Der Wolfsmann" (*Aus der Geschichte einer infantilen Neurose*, 1918); vgl. dazu auch Jean Laplanche und J.-B. Pontalis, *Das Vokabular der Psychoanalyse*, Frankfurt am Main 1994, S. 313–317, sowie Jacques Derrida, *Die Schrift und die Differenz*, Frankfurt am Main 1976, S. 302–350.
5 Gilles Deleuze, „Über das Bewegungs-Bild" (1983), in: *Unterhandlungen 1972–1990*, Frankfurt/M, 1993, S. 70–85: 80.
6 Ausführliche Überlegungen zu *ION ON*: Julian Heynen, „*ION ON* – Ein Film", in: *Bethan Huws, Selected Textual Works 1991–2003*, a.a.O., S. 167–169. Das 45 Szenen umfassende Script des Films *ION ON* (2001–2003) – „A critical comedy" – findet sich im gleichnamigen Katalog publiziert.

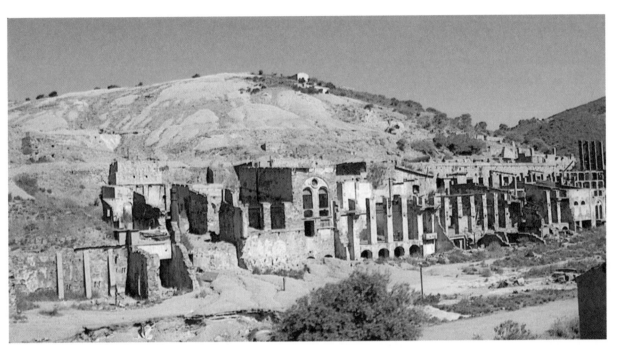

Scene 1

Scene 4

Scene 3

Scene 31

Scene 4

Scene 32

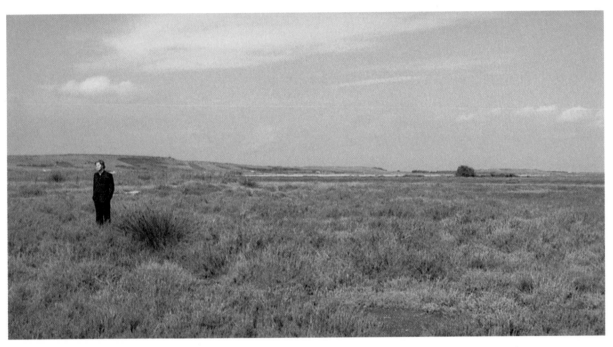

Scene 10

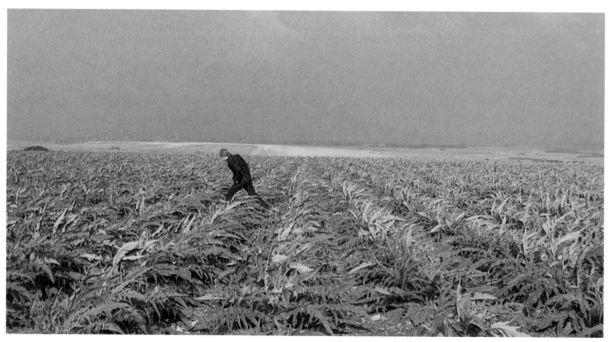

Scene 6

DARK Atmosphere.

(All floor cloths are not equal

FLAT Field.

[20]

T3 0:29:30:24
is not Airawana [26.] IONE ON/ SCENE 6.

SKY.

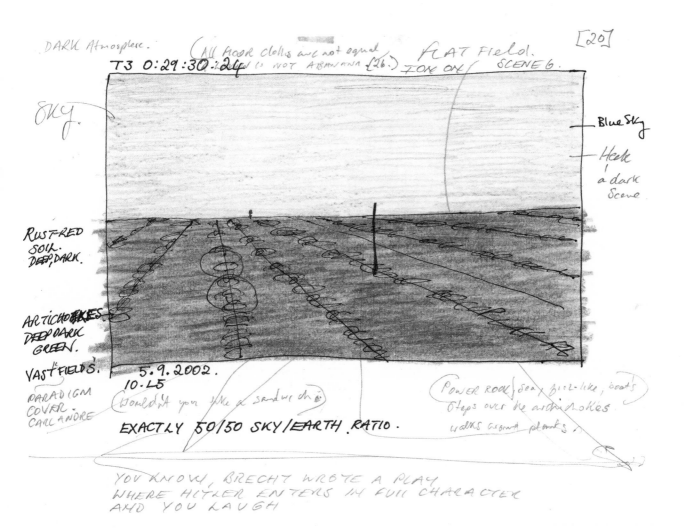

Blue Sky

Heek
a dark
Scene

RUST-RED
SOIL.
DEEP, DARK.

ARTICHOKES
DEEP DARK
GREEN.

VAST FIELDS.

PARADIGM
COVER.
CARL ANDRE

5.9.2002.
10.L5
(Wouldn't you like a sandwich)

EXACTLY 50/50 SKY/EARTH RATIO.

(POWER ROCK) Sea & Bird-like, boat's
Steps over the artichokes.
walks around planks /

YOU KNOW, BRECHT WROTE A PLAY
WHERE HITLER ENTERS IN FULL CHARACTER
AND YOU LAUGH

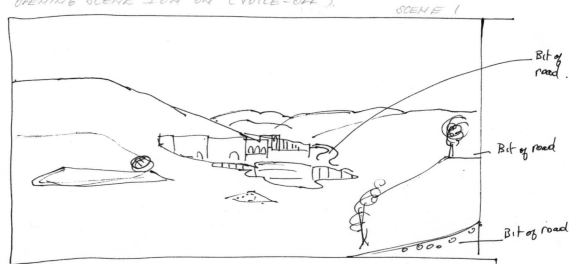

Bit of road.

Bit of road

Bit of road

SHOW TRAVELLING. PICK-UP VAN
All. 5 MINUTES ROLL.

Keep sky at about same ratio.

STARTS AT EXTREME LEFT.
STATIC AT FIRST.

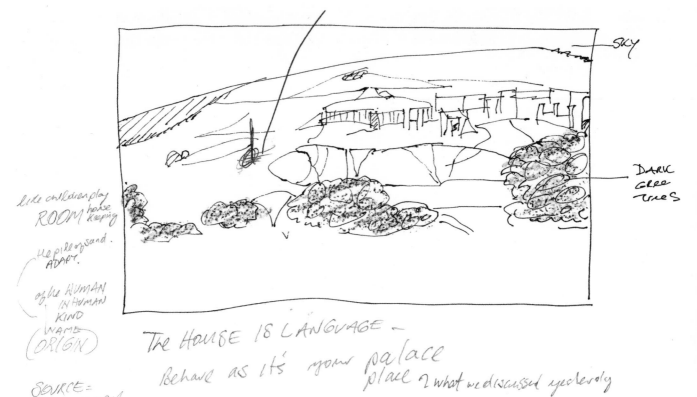

SKY

DARK GREE TREES

like children play
ROOM house keeping

the pile of sand.
ADAM.

of the HUMAN
IN HUMAN
KIND
NAME
(ORIGIN)

The HOUSE IS LANGUAGE —
Behave as it's your palace
place ? what we discussed yesterday

SOURCE =
living speech
the current burr.
LINGUISTIC field. SECTOR SECTION 1

MOUND.
(Beautiful.)

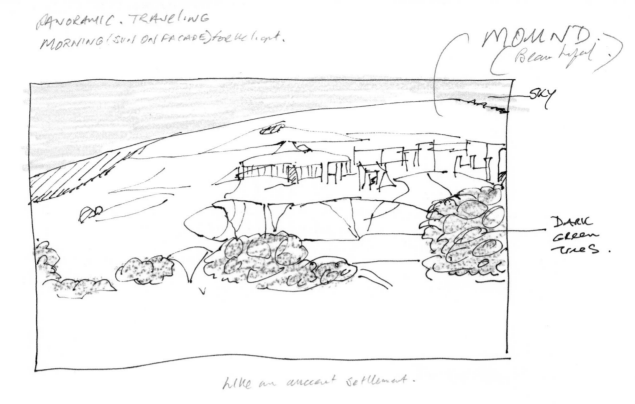

SKY

DARK
GREEN
TREES.

Like an ancient settlement.

CHOICE

NO ROADS. ON THE ROAD

(OFF)

trees.

SANDY.
AND BRICK
HILLS

OPENING SCENE 7 ON ON (VOICE-OFF) SCENE 1

WHITE-
BLUE
SKY.

DARK
GREEN.

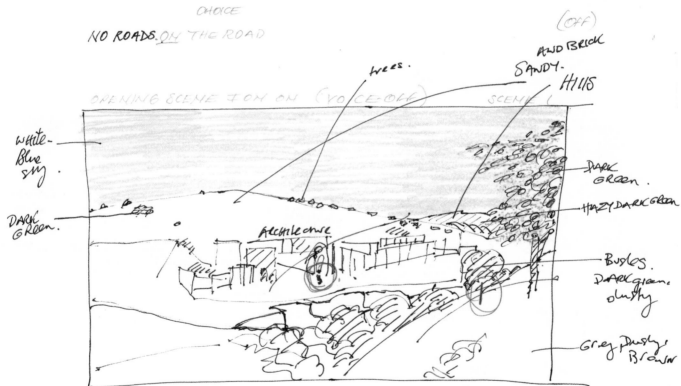

Architecture

DARK
GREEN.

HAZY DARK GREEN

BUSHES.
DARK GREEN.
dusty

Grey Dusty
Brown

T.3 0:06:19:13.

SCENE 3

14:53

T.3 0:06:40:15.

SCENE 3

"Brilliant"
view of
CHURCH WINDOW
AND 4 PILLAR HA
AN

14:54

tidroak green Brush.

Blue; whole clouds. (Michaelayelo.)

7

Arh chogue green Lakke

BROWN.

FINE. yellow sand. sand said

TRAVELING CAMERA swivels around, field A LEMON IS NOT A BANANA.

T4 0:04:00:19 CLOSING SCENE SCENE 45

12:02 5.9.2002. NEAR CABAN
THE THINEST (INFRA THIN COAT OF WATER POSSIBLE)
VERY FLAT.

REPERAGE 0:31:20:12 *CABRAS* SCENE 17 *VIS ART IIIIT*

15:32 6.8.2002. THIS FIELD RUNS PARALLEL WITH GREEN LAKE.
 V.V.V.SHORT GRASS - BURNT BROWN SIENA.
 60-70/LAND/— SKY RATIO

OR FOR SCENE 29
The artists they say they respect the most usually ones they
never buy and pay the least

 SCENE 7

Yellow.

BATCHES of
BRUDES
on slope. Slope

 Hills

Heavy
tree.

THICK
GRASS
LIGHTER, FRESHER
GREEN, wet.

Yellow
SAND

 Those directions given. SIGN, sing?

H's Ailey Herrons again. (Pause) SCENE 37 The ups and downs.

Blue
sky.

HAZE.
mountains

foreground
Sand
piled up

DUNE.
DRY.
YELLOW.
VIVID.

(you can't do that.) [28] Complex little trip this. (at the derelic position
ION ON SCENE 39 is E Meth.

sky.

HAZY
MOUNTAINS

DARK GREEN
BUSHES

Blue
GREEN
YELLOW
BLACK

FOUR COLORED DRAW
ING

A space w.h bits and pieces in it of remnants.
Of various sizes, shapes, orientations, qualities, hard/soft—
elementy objects. ANTONYMIC
PARADIGM

Baguette.(yellow.)context LEMON
Lemon — reoccuring joke throughout FRESH
 CLEAN
 SHARP
 PARADIGM

149

T.3 O:14:20:10

SCENE 4

18:48

STILL FRAME FIRST.

T.3 O:14:37:16

SCENE 4

18·53

150

INSERT.

ORANGE RUST RIVER (AWAY FROM WATER). (THEN BACK
LOGIC ETHICS ~~AND~~ ESTHETICS ARE ONE...! SPARK... NEURON... AGAIN.)
SCENE 22

Sky.

COLOUR =
WITTIGENSTEIN
relation to

CAMERA QUITE LOW DOWN IRON = METAL

T.3 0 : 13 : 38 : 04 SCENE 22

18:09

151

FOUNTAIN 16 MM COLOR FILM FORTY NINE ROMAN FOUNTAINS FROM
VARIOUS PERIODS WERE FILMED

PIAZZA SAN SIMEONE. ACCOMPANIED BY A VOICE-OFF
ON MARCEL DUCHAMP'S FOUNTAIN

TAPE 2 FRAME 12 2

LIGHT IS REFLECTING AND
MOVING TO AND FRO ON FIGURES
FACE.
MOVING LIGHT. REFLECTIONS MOVING
 WATER ON STONE.

PIAZZA CAMPITELLI FOUNTAIN

FOUNTAIN 6 / 10 views

NO WATER, IN OLLU WORDS, DRY.

⑤ IN LIGHT OR LIT.

VERY STATIC FRAME
NO MOVEMENT.
LIKE A PHOTOGRAPH. PETRIS

② but much later
ON IN the tape

IN
HEAVY
SHADOW

The STEM OF
FOUNTAIN

DESERT.
PARCHET.
COUGH.
DRY CHOOKE
NO WATER RUNNING

154

FROG FOUNTAIN

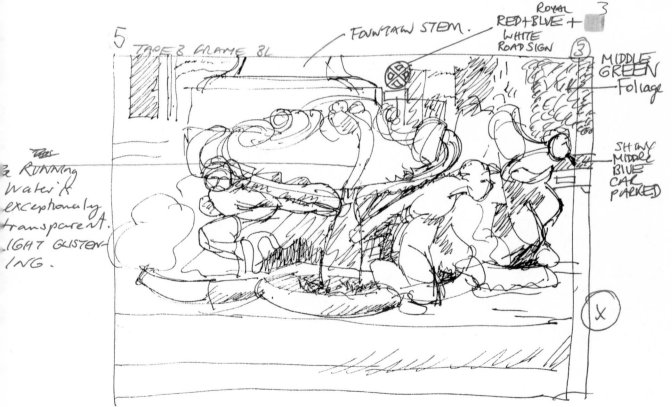

5 TAPE 3 FRAME 3L

FOUNTAIN STEM.

ROYAL
RED+BLUE +
WHITE
ROAD SIGN

3

MIDDLE
GREEN
Foliage

SHINY
MIDDLE
BLUE
CAR
PARKED

& RUNNING
Water's
exceptionally
transparent.
IGHT GLISTEN-
ING.

X

TAPE 8 FRAME 13
MUCH MOVEMENT.

Filling the SCREEN
The BOWL
③

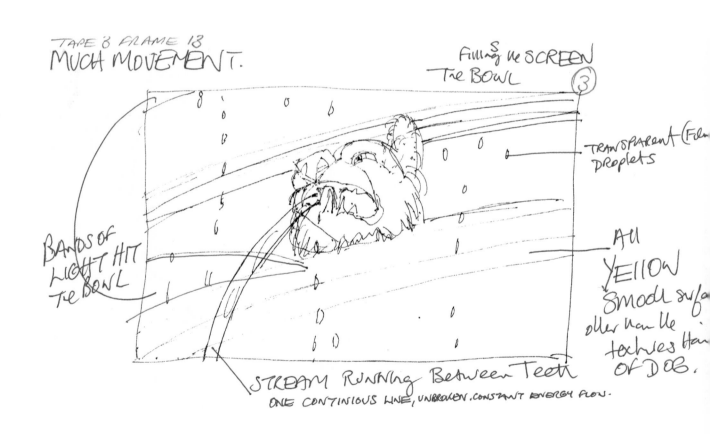

TRANSPARENT (Film)
DROPLETS

BANDS OF
LIGHT HIT
The BOWL

ALL
YELLOW
Smooth surface
other than the
textures Hair
OF DOG.

STREAM Running Between Teeth
ONE CONTINIOUS LINE, UNBROKEN, CONSTANT ENERGY FLOW.

FOUNTAIN SANTA MARIA, TRASTEVERE
[DOG-WOLF FOUNTAIN]

Yellow Ochre.

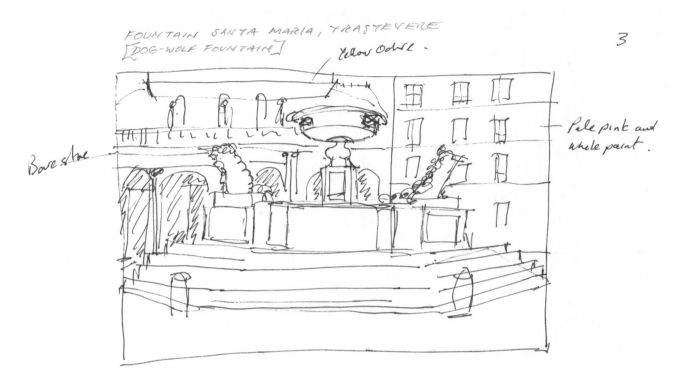

Bare Stone

→ Pale pink and white paint.

A Saturated Blue violet Sky. The DOG FOUNTAIN.
 3 STATUES.
 TAPE 8 FRAME 9

ARCHITECTURAL FULL FRAME PALEST PINK PAINT with white Borders

Yellow Ochre.

③ 3

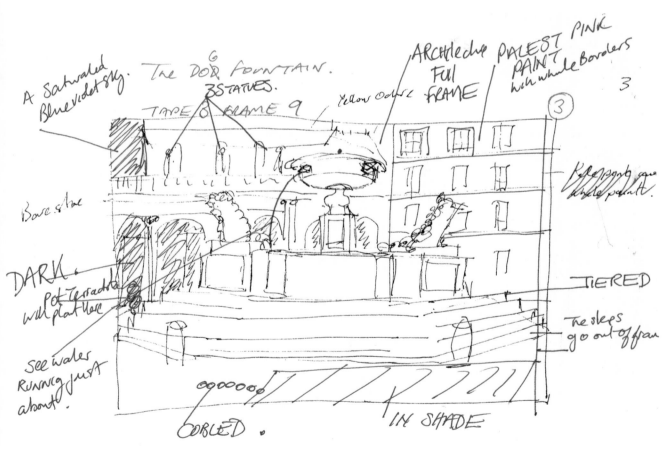

Bare Stone

DARK.
Pot Terracotta
with plant here

See water
Running just
about.

TIERED

Pale paint and
white paint.

The steps
go out of frame

COBLED.

IN SHADE

CONTRE JOUR

DARKENED
STEM OF VASK.

UNDERNEATH the vases the FIGURES, shelters from
mouth piece of cherub and cheek

③ TAKE 2 FRAME 47 CLOSEUP OF BACKS.

Turtle
Tips of feet and tails

Beautifull

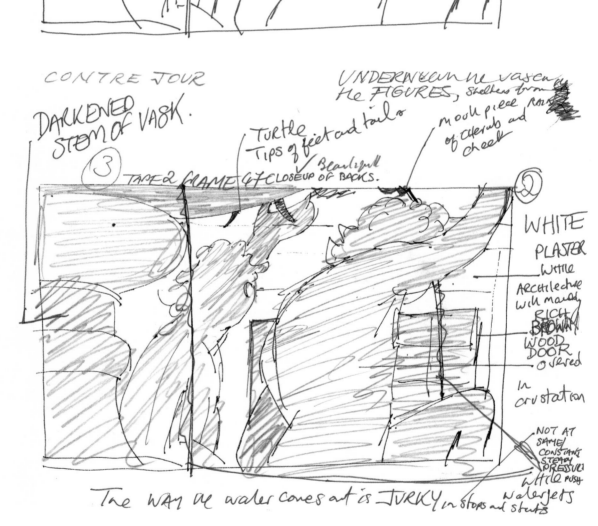

WHITE
PLASTER
With the
architecture
with mainly
RICH
BROWN
WOOD
DOOR
overed

In
crustation

NOT AT
SAME
CONSTANT
STEADY
PRESSURE
White pushy
waterjets

The WAY the water comes out is JURKY in stops and starts

BABUINO "SIMPLETON" FOUNTAIN VIA(?) "GRAFFITI" FOUNTAIN

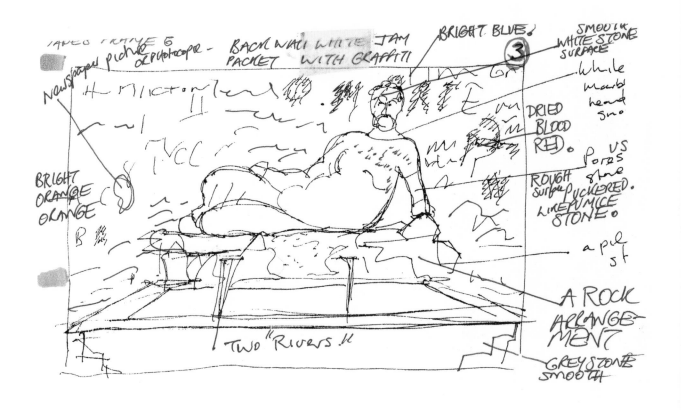

Catalogue List

Bethan Huws

1961 born in Bangor, Wales
Lives and works in Paris, France

2007–08 DAAD Artist-in-Residence,
Berlin, Germany
2006 B.A.C.A. Biannual Award for
Contemporary Art in Europe,
Bonnefantenmuseum, Maastricht,
The Netherlands
2004 Ludwig Gies-Preis für Kleinplastik der
LETTER Stiftung, Cologne, Germany
1999–00 The Henry Moore Sculpture
Fellowship, The British School at Rome,
Italy
1998 Adolf-Luther-Stiftung Kunst-Preis,
Krefeld, Germany
1986–88 Royal College of Art, London,
England
1981–85 Middlesex Polytechnic, London,
England

Solo Exhibitions

2006–07 *B.A.C.A. Award,*
Bonnefantenmuseum Maastricht,
The Netherlands
Kunstmuseum St.Gallen, St.Gallen,
Switzerland
2006 Galerie Friedrich, Basel, Switzerland
Filme, Institute für Kunst und Medien der
HGK, Zürich, Switzerland
2005–06 *The Chocolate Bar,* Chapter Arts
Centre, Cardiff, Wales
2004 Galerie Tschudi, Glarus, Switzerland
ION ON, Singing for the Sea,
Tate Modern, London, England
2003 *Foyer,* Kunsthalle Düsseldorf,
Düsseldorf, Germany (cat.)
Galerie Friedrich, Basel, Switzerland
ION ON, Chapter Arts Centre, Cardiff,
Wales
Word-Vitrines, K21, Kunstsammlung
Nordrhein-Westfalen, Düsseldorf,
Germany
2002 Produzentengalerie, Hamburg,
Germany
2001 *On What?* Henry Moore Institute,
Leeds, England
Yorkshire Sculpture Park, Bretton Hall,
Wakefield, England
Springhornhof Kunstverein,
Neuenkirchen, Germany
2000 Galerie Friedrich, Bern, Switzerland

Städtische Galerie im Lenbachhaus,
München, Germany (cat.)
1999 Bonakdar Jancou Gallery, New York,
USA
Oakville Galleries, Oakville, Ontario,
Canada (cat.)
Produzentengalerie, Hamburg, Germany
1998–99 *Watercolours,* Kaiser Wilhelm
Museum, Krefeld, Germany;
Kunstmuseum, Bern, Switzerland;
Oriel Mostyn Art Gallery, Llandudno,
Wales (cat.)
1998 Galerie Poo Poo, Bank, London,
England
1997 Galerie Hollenbach, Stuttgart,
Germany
Galerie Friedrich, Bern, Switzerland
1996 Galerie Karlheinz Meyer, Karlsruhe,
Germany
1994 Galerie Luis Campaña, Köln,
Germany
1993 Museum Haus Esters, Krefeld,
Germany
A Work for the North Sea, Alnwick,
organised by Artangel, London,
England
Galerie Friedrich, Bern, Switzerland
1992 Galerie Luis Campaña, Frankfurt
am Main, Germany
Produzentengalerie, Hamburg, Germany
Galerie Karlheinz Meyer, Karlsruhe,
Germany
1991 Galerie Luis Campaña, Frankfurt
am Main, Germany
The Institute of Contemporary Arts,
London, England (cat.)
1990 Kunsthalle Bern, Bern, Switzerland.
(cat.)
1989 Riverside Studios, London,
England

Group Exhibitions

2006 *Mental-Image,* Kunstmuseum
St.Gallen, St.Gallen, Switzerland,
curated by Konrad Bitterli
Summer Show, Galerie Tschudi, Zuoz,
Switzerland
Textual Works, New Langton Arts,
San Francisco, USA, curated by Sandra
Percival
2005–06 *Brought to Light,* Oriel Mostyn
Gallery, Llandudno, Wales, curated by
Martin Barlow (cat.)

A Brief History of Invisible Art, CCA Wattis
Institute, San Francisco, USA, curated by
Ralph Rugoff (cat.)
2005 *Over & Over, Again & Again,*
Contemporary Art Centre, Vilnius,
Lithuania, curated by Hannah Firth (cat.)
Art made of Chocolate, Ludwig Museum,
Köln, Germany, curated by Kasper König
(cat.)
ERYRI-A Sense of Place, Gwynedd
Museum & Art Gallery, Bangor, Wales
(cat.)
Winter Show, Galerie Tschudi, Zuoz,
Switzerland
2004 *Hauptwerke der Sammlung,* Kolumba,
Diozesanmuseum, Köln, Germany
Summer Show, Galerie Tschudi, Zuoz,
Switzerland
Spread in Prato 2004, Dryphoto arte
contemporanea, Prato, Italy, curated by
Pier Luigi Tazzi (cat.)
9. Triennale Kleinplastisk Fellbach,
Stuttgart, Germany, curated by Jean-
Christophe Ammann (cat.)
Congregation, Picture This Moving Image,
Bristol, England
2003–04 *Further,* Aberystwyth Art Centre,
Aberystwyth, Wales; Glynn Vivian Art
Centre, Swansea, Wales;
National Museums and Galleries of
Wales, Cardiff, Wales (cat.)
2003 *Celebrate/Dathlu,* Oriel Davies Gallery,
Newtown, Wales
The Translator's Notes, Cafe Gallery,
London, England, curated by Irene
Amore
ION ON, Wales at the Venice Biennale,
Italy, curated by Michael Nixon and
Patricia Fleming (cat.)
2002 *The Museum, the Collection, the Director
and his Loves,* Museum für Moderne
Kunst, Frankfurt am Main, Germany
Work on Paper, Galerie Friedrich, Basel,
Switzerland
Private view, la mia normalita, la tua follia,
Blodo, Firenze, Italy, curated by Pier
Luigi Tazzi
Opening, Galerie Friedrich, Basel,
Switzerland
STARTKAPITAL, K 21, Kunstsammlung
Nordrhein-Westfalen, Düsseldorf,
Germany, curated by Julian Heynen (cat.)
Regarder la mer, repenser le monde,

Le Grande Café, Saint Nazaire, France, curated by Sophie Legrandjacques
Basics, Kunsthalle Bern, Switzerland, curated by Bernhard Fibicher (cat.)
Zeitmaschine-Time Machine, Kunstmuseum Bern, Switzerland, curated by Hans Rudolph Reust (cat.)

2001 *Self/Portrait*, National Museums and Galleries of Wales, Cardiff, Wales
R, Produzentengalerie, Hamburg, Germany
Musée National d'Art Moderne, Centre Georges Pompidou, Paris, France
Sammlung Thomas Olbricht, Neues Museum Weserberg, Bremen, Germany (cat.)
Kleine Paradiese, im Gustpark Böckel, Garten-Landschaft OstWestFalenLippe, Germany, curated by Thomas Kellein (cat.)

2000 *Finale de partita*, Biagiotti Arte Contemporanea, Firenze, Italy, curated by Pier Luigi Tazzi (cat.)
Watercolours, The Henry Moore Institute, Leeds, England, curated by Penelope Curtis
Afon/River, Oriel Mostyn Gallery, Llandudno, Wales, curated by Martin Barlow
The idea of north, City Arts Gallery, Leeds, England, curated by Nigel Walsh
Drehmomente, Sammlung Hauser und Wirth, St.Gallen, Switzerland, curated by Ulrike Groos (cat.)
Mixing Memory and Desire, Kunstmuseum Luzern, Switzerland, (cat.), curated by Ulrich Loock (cat.)

1999 *Drawings*, Bonakdar Jancou Gallery, New York, USA
Am Horizont, Kaiser Wilhelm Museum, Krefeld, Germany, curated by Julian Heynen (cat.)
Readymades belong to everyone, Produzentengalerie, Hamburg, Germany
Harlech Art Biennale 3, Neuadd Goffa Harlech, Wales (cat.)
Ex-Tension, Het Domein Museum, Sittard, The Netherlands, curated by Pier Luigi Tazzi
Forget about the ball and keep playing, Kunsthalle Nurnberg, Germany (cat.)
Superstructure, Centre for Visual Arts, Cardiff, Wales (cat.)

1998 *7. Triennale der Kleinplastik*, Forum Sudwest LB, Stuttgart, Germany (cat.)
Wahlverwandtschaften, Art&Appenzell, Appenzell, Switzerland (cat.)
Clean slate, Art Gallery of New South Wales, Sydney, Australia, curated by Wayne Tunnicliffe (cat.)
Ethno-Anthics, Nordiska Museum, Stockholm, Sweden, curated by Lynne Cooke (cat.)
New Art from Britain, Kunstraum, Innersbruck, Germany, curated by Peter Murray (cat.)
Llathyard, Centre for Research in Fine Art, Cardiff, Wales, curated by Melanie Jackson (cat.)
Voice Over, National touring exhibition from the Hayward Gallery, London, England, curated by Michael Archer, Greg Hilty (cat.)

1997–99 *At the Threshold of the Visible: Minuscule and Small Scale Art, 1964–1996*, touring exhibition organised by Independent Curators International, New York, USA, curated by Ralph Rugoff (cat.)

1997–98 *Pictura Britannica*, Museum of Contemporary Art, Sydney, Australia, touring exhibition curated by Bernice Murphy (cat.)

1997 *Eté*, Centre Genevois de Gravure Contemporain, Genève, Switzerland
Skulptur. Projekte in Münster 1997, Westfälisches Landesmuseum, Münster, Germany, curated by Kasper König (cat.)
Niemandsland, Museum Haus Lange/ Haus Esters, Krefeld, Germany, curated by Julian Heynen (cat.)
Résonances, Galerie Art'o, Aubervilliers, France, curated by Elvan Zabunyan (cat.)

1996 *Life/Live*, Centro Cultural de Belem, Lisbon, Portugal
Life/Live, ARC– Musée d'Art Moderne de la Ville de Paris, France, curated by Laurence Bossé, Hans-Ulrich Obrist (cat.)
Kunststiftung Sabine Schwenk, Haigerloch, Germany
Private View, The Bowes Museum, Barnard Castle, England, curated by Penelope Curtis, Veit Görner (cat.)
Produzentengalerie, Hamburg, Germany

1995 Galerie Friedrich, Bern, Switzerland

Galerie Luis Campaña, Köln, Germany
Uscita di sicurezza, Sala Cassero, Castel San Pietro Terme, Italy, curated by Pier Luigi Tazzi (cat.)
Insomnie, Domaine de Kerguehennec, Locimé, France, curated by Denys Zacharopoulos (cat.)

1994 *Welt-Moral*, Kunsthalle Basel, Switzerland, curated by Thomas Kellein (cat.)

1993 *On taking a normal situation...*, Antwerp 93, Museum Van Hedendaagse Kunst, Antwerp, Belgium, curated by Yves Aupetitallot, Iwona Blazwick, Carolyn Christov-Bakargiev (cat.)
De la main à la tête, l'objet théorique, Domaine de Kerguehennec, Locimé, France, curated by Denys Zacharopoulos (cat.)

1992 *Oh! Cet echo!*, Centre Cultural Suisse, Paris, France, curated by Bice Curiger, Bernard Marcadé, Hans-Ulrich Obrist (cat.)
Gemischtes Doppel, Wiener Secession, Vienna, Austria, curated by Hildegund Amanshauser, Helmut Draxler, Kasper König, Kristian Sotriffer (cat.)

1990 *The British Art Show*, a touring exhibition organised by The South Bank Centre, London, England, curated by Caroline Collier, Andrew Nairne, David Ward (cat.)

1989 *Les Grâces de la Nature*, Sixièmes Ateliers Internationaux des Pays de la Loire, Gétigné, France, curated by Jean-Francois Taddei, Mario Toran (cat.)

1988 Anthony Reynolds Gallery, London, England (cat.)
Royal College of Art, London, England (cat.)
56/57 Rivington Street, London, England

1987 Institute Sainte Marie, Bruxelles, Belgium (cat.)
Royal College of Art, London, England

Bibliography

2006 Scharrer, Eva. *Bethan Huws: Galerie Friedrich.* Critics' Picks, Artforum April

Naef, Maja. *The Chocolate Bar.* Premiere-Chapter Arts Centre, February 2006

Adams, David. *The Chocolate Bar,* The Western Mail, Friday February 10

2005 Myers, Julian. *A Brief History of Invisible Art.* Frieze no. 12

2004 Kock Marti, Claudia. *Was zum Teufel machen Sie hier...?* Glarnerland, 01/10/04

Kuoni, Gisela. *Bethan Huws: Galerie Tschudi.* Kunstbulletin no. 12

2003 Adams, David. *ION ON.* The Western Mail, Friday April 4

Lorch, Cathrin. *Bethan Huws in der Kunsthalle Düsseldorf.* Kunst Bulletin, no.10

Heynen, Julian. *Bethan Huws: ION ON.* Catalogue Further, Artists from Wales, Biennale Venice

Gorschlüter, Peter. *Bethan Huws: Foyer.* Vernissage, 01/03–03/03

Hafner, Hans-Jürgen. *Bethan Huws-Foyer.* Kunstforum International, no.167

2002 Fibicher, Bernhard. *Basic.* Catalogue published by Kunsthalle Bern

Searle, Adrian. *Off Limits 40 Artangel projects*, published by Artangel/Merrell

2001 Gebur, Thomas. *Bethan Huws.* Catalogue Die Sammlung Olbricht Teil 2

2000 Groos, Ulrike. *Bethan Huws Drehmoment*, published by Sammlung Hauser und Wirth

Tazzi, Pier Luigi. *Finale di partita.* Catalogue published by Biagiotti Progetto Arte

Ackermann, Marion. *Federn.* published by Städtische Galerie im Lenbachhaus, München

1999 Godfrey, Tony. *Bethan Huws.* Art Monthly, no.227

Farquharson, Alex. *Bethan Huws.* Frieze, no.48

Barlow, Martin. *Certain Welsh Artists.* Catalogue published by Seren

1998 Reust, Hans-Rudolf. *Vor dem beginnen mit Kunst.* Kunst Bulletin, no.1/2

Salden, Hubert. *Bethan Huws.* Catalogue New Art From Britain

1997 Huebl, Michael. *Skulptur.Projekte Münster.* Kunstforum International, no.138

1995 Tazzi, Pier Luigi. *Bethan Huws.* Catalogue Uscita di Sicurezza

1994 Huebl, Michael. *On taking a normal situation...* Kunstforum International, no.125

Wulfen, Thomas. *Bethan Huws.* Kunstforum International, no,125

1993 Archer, Michael. Bethan Huws/Bistritsa Babi, A Work for the North Sea. Art Monthly, no.169

Muir, Gregor. Bethan Huws, A Work for the North Sea. Frieze, no.12

Christov-Bakargiev, Carolyn. *Antwerp 93.* Kunst & Museum Journal, no.1

Wilson, Andrew. *Antwerp 93.* Art Monthly, no. 171

1992 Kravagna, Christian. *Gemischtes Doppel.* Kuntsforum International, no.120

Loock, Ulrich. *Works-Thinking up a Place.* Catalogue Gemischtes Doppel

Gillick, Liam. Making a work and turning your back on it. Parkett, no.32

1991 Vogel, Sabine B. *Bethan Huws.* Artforum International, September

Renton, Andrew. *Bethan Huws ICA.* Flash Art, no.162

Lillington, David. *Pooled Ideas.* Time out, November 13–20

1990 Bachelor, David. *Bethan Huws.* Artscribe International, no.76

Gillick, Liam. Critical Dementia, The British Art Show. Art Monthly, no.134

Wechsler, Max. *Lisa Milroy/Bethan Huws.* Artforum International, October

1989 Hilton, Tim. *Bethan Huws.* The Gardian, Wednesday August 9

Gillick, Liam. *Bethan Huws.* Art Monthly, no.130

Kent, Sarah. *On Installation.* Time Out, no.992

Craddock, Sacha. *Bethan Huws.* The Guardian, Tuesday August 29

Costa, Vanina. *Bethan Huws.* catalogue Sixièmes Ateliers Internationaux des Pays de la Loire

1988 Archer, Michael. *Bethan Huws.* Artscribe International, no.72

Publications

2006 *Bethan Huws: B.A.C.A Europe,* texts by Konrad Bitterli, Maja Naef, interview by Julian Heynen. Published by Bonnefantenmuseum, Maastricht, The Netherlands

2005 *Bethan Huws: Singing to the Sea,* texts by Michael Archer, Iwona Blazwick, Bethan Huws, Ulrich Loock, Pier Luigi Tazzi, interview by James Lingwood. Edited and published by Dieter Association, Paris, France

2003 *Bethan Huws: Selected textual works 1991–2003,* texts by Penelope Curtis, Emma Dexter, Ulrike Groos, Julian Heynen, Bethan Huws, Kasper König, Ulrich Loock, Hans-Rudolf Reust, Hubert Salden, Gregory Salzman Christoph Schenker. Edited by Dieter Association, Paris, published by Dieter Association / Kunsthalle Düsseldorf, Germany

1998 *Bethan Huws: Watercolours,* texts by Josef Helfenstein, Julian Heynen, Ulrich Loock. Edited by Julian Heynen, published by Krefelder Kunstmuseen, Krefeld, Germany

1991 *Bethan Huws: Works 1987–1991,* texts by Emma Dexter, Bethan Huws, Ulrich Loock, interview by James Lingwood. Edited by Ulrich Loock, published by Kunsthalle Bern, Switzerland / ICA London, England

Published in conjunction with the exhibition
'Bethan Huws' on the occasion of the
'B.A.C.A. 2006 Europe Award'

Exhibition: Bethan Huws and Paula van den Bosch,
Bonnefantenmuseum

September 24, 2006 – January 14, 2007
Bonnefantenmuseum, Maastricht, The Netherlands

February 24 – May 13, 2007 Kunstverein St.Gallen
Kunstmuseum, Switzerland

Edited by
Bonnefantenmuseum
Kunstverein St.Gallen Kunstmuseum

Edition 1500

Translations
Kevin Cook (D/E), Jeanne Haunschild (G/E),
John Rayner (G/E), Ralf Schauff (E/G),
Karl Schillings (D/G) and Jacqueline Todd (G/E)

Editing / Co-ordination
Ineke Kleijn

Graphic Design
Peter Willberg, London

Photocredits
© Dieter Association, Paris; Bethan Huws, Paris;
Hugo Glendinning, London; Achim Kukulies,
Düsseldorf; Jeannette Merh, Basel;
Mancia/Bodner Studio, Zürich; John Riddy, London;
Franck Thurston, London and Steve White, London

Published by
Verlag der Buchhandlung Walther König
Ehrenstr. 4, 50672 Cologne
Tel. +49 (0)221 /20 59 6-53
Email: verlag@buchhandlung-walther-koenig.de

Distribution outside Europe
D.A.P. / Distributed Art Publishers, Inc., New York
155 Sixth Avenue, New York, NY 10013
Tel. 212-627-1999 Fax 212-627-9484

ISBN 90-72251-38-5 (Museum edition,
only available in the Bonnefantenmuseum)

ISBN 13: 978-3-86560-114-8 (Trade edition)

Printed in Germany

Kunstverein St.Gallen Kunstmuseum
Museumstrasse 32
CH - 9000 St.Gallen
info@kunstmuseumsg.ch
www.kunstmuseumsg.ch

Director: Roland Wäspe
Curator: Konrad Bitterli
Assistance: Nadia Veronese
Secretariat: Alexandra Hänni
Press and Public Relations: Christine Kalthoff-Ploner
Technical Department: Urs Burger
The Kunstverein St.Gallen receives long-term support
from the city and county of St.Gallen.

Bonnefantenmuseum
P.O. Box 1735
NL – 6201 Maastricht
info@bonnefanten.nl
www.bonnefanten.nl

The Bonnefantenmuseum receives long-term support
from the Province of Limburg

provincie limburg

océ

Gemeente Maastricht

The Bonnefantenmuseum, Kunstmuseum St.Gallen
and Bethan Huws would like to thank:
Erika and Otto Friedrich, Galerie Friedrich Basel; Ruedi
Tschudi and Elsbeth Bisig, Galerie Tschudi Glarus &
Zuoz; Jürgen Vorrath, Produzentengalerie Hamburg;
Julian Heynen, K21 Kunstsammlung Nordrhein-
Westfalen, Düsseldorf and Maja Naef, Universität
Basel.

Bethan Huws wishes to thank:
Michael Archer, Pawel Althamer, Ruedi Bechtler,
Konrad Bitterli, Iwona Blazwick, Paula van den Bosch,
Luis Campaña, María de Corral, Penelope Curtis,
Emma Dexter, Charles Esche, Alexander van
Grevenstein, Ulrike Groos, Josef Helfenstein,
Julian Heynen, Rhys Ifans, Jude Kelly, Ineke Kleijn,
Kasper König, James Lingwood, Romy Lipp, Tim
Llewellyn, Ulrich Loock, Hans Rudolf Reust, Anthony
Reynolds, Gruff Rhys, Ralph Rugoff, Christoph
Schenker, Marco Schibig, Franziska Schott, Gerard
James Smurthwaite, Pier Luigi Tazzi, James Tyson,
Roland Wäspe.

Special thanks to the lenders who where so generous
to loan the works for the exhibition:
Kunstmuseum, Bern; Fonds National d'Art
Contemporain – Ministère de la Culture et de la
Communication, Paris; Kaiser Wilhelm Museum,
Krefeld; Galerie Friedrich, Basel; Galerie Tschudi,
Glarus-Zuoz; Produzentengalerie, Hamburg; Hans
Bollier, Zürich; Franziska Schott and Marco Schibig,
Bern; Marlies Ammann, Basel; Bettina Steigenberger,
Vienna and lenders who wish to remain anonymous.

As well as the institutions and foundations which
have supported the production of the film ION ON,
2003 and The Chocolate Bar, 2006:
The Henry Moore Foundation UK, The American
Center Foundation New York, Chapter Arts Centre
Cardiff, Dieter Association Paris, La Délégation aux
Arts Plastiques – Ministère de la Culture et de la
Communication Paris and Le Fresnoy Tourcoing for
the support of the film ION ON and
The Arts Council of Wales Cardiff, Esmée Fairbairn
Foundation UK, The Elephant Trust London, Chapter
Studio Cardiff and Dieter Association Paris for the
support of the film The Chocolate Bar.

On the cover: Royal College Piece, Sculpture School,
Queen's Gate, London, 1988